ART LESSONS
FOR THE
MIDDLE SCHOOL
A DBAE CURRICULUM

NANCY WALKUP REYNOLDS

J. WESTON
WALCH
PUBLISHER
PORTLAND, MAINE

Users' Guide
to
Walch Reproducible Books

As part of our general effort to provide educational materials which are as practical and economical as possible, we have designated this publication a "reproducible book." The designation means that purchase of the book includes purchase of the right to limited reproduction of all pages on which this symbol appears:

Here is the basic Walch policy: We grant to individual purchasers of this book the right to make sufficient copies of reproducible pages for use by all students of a single teacher. This permission is limited to a single teacher, and does not apply to entire schools or school systems, so institutions purchasing the book should pass the permission on to a single teacher. Copying of the book or its parts for resale is prohibited.

Any questions regarding this policy or requests to purchase further reproduction rights should be addressed to:

Permissions Editor
J. Weston Walch, Publisher
P.O. Box 658
Portland, ME 04104-0658

—J. Weston Walch, Publisher

1 2 3 4 5 6 7 8 9 10

ISBN 0-8251-2143-4

Contents

The Middle School Art Program

Art, Grade Six

Art, Grade Six, is a basic, introductory one- or two-semester course designed to introduce the student to the elements and principles of design through work with a variety of media and techniques, and to develop the student's abilities to make critical judgments about art and to understand and appreciate the influences of art from other times and cultures. This first course of art should be a prerequisite for further study.

Art, Grade Seven

Art, Grade Seven, is an intermediate one- or two-semester course designed to build upon and increase the student's knowledge of the elements and principles of design and familiarity with an increased variety of media and techniques. A continued emphasis on critical judgment is accompanied by an increased focus on art from other cultures. This course should be a prerequisite for Art, Grade Eight.

Art; Grade Eight

Art, Grade Eight, is an advanced one- or two-semester course for the serious student and is designed to expand the student's knowledge, abilities, and critical judgment; to introduce new media and skills; and to emphasize art history.

Rationale

Discipline-Based Art Education is an approach to teaching art that makes use of four foundational art disciplines to teach art concepts and skills through a written, sequential course of study. These disciplines are art production, art history, art criticism, and aesthetics.

A discipline-based art curriculum, with its balance of content from four disciplines, provides a viable means of presenting interdisciplinary, cross-curricular studies in the humanities while helping students develop perceptual awareness, critical thinking skills, and an understanding of art. Throughout this curriculum, students will react effectively to, analyze, talk about, and write about art, as well as create it. In this curriculum, art is considered a basic subject in general education, one that should be available at all grade levels to all students in the middle school.

Instruction is concept-centered, sequential, and cumulative, and integrates the four art disciplines, unlike previous curricula which focused primarily on art production. The making of art must be interrelated with aesthetic perception, critical evaluation, and an understanding of the cultural and historical influences of art for art education to become a meaningful part of the general curriculum.

This guide is a suggested outline of study, based on an orderly learning sequence of sequential and cumulative instruction. Adjustments for the needs of specific students, classes, and situations rely upon the discretion of the individual teacher.

Program Objectives

Students will master the following objectives:

1. Define, recognize, and use the elements of art.
2. Define, recognize, and use the principles of design.
3. Recognize, distinguish, and appreciate art and cultural influences of differing cultures and historical periods.
4. Develop an awareness of and sensitivity to art in both natural and human-made environments.
5. Strengthen perceptual awareness and cognitive skills through sensory experiences.
6. Analyze, compare, interpret, and evaluate art of self, other students, and major artists.
7. Communicate feelings and ideas through creative visual expression.
8. Develop skills in producing visual art in a wide variety of media and techniques.
9. Exhibit proficiency in terminology and techniques related to areas of art study.
10. Explore careers in the field of art.
11. Develop skills in the care and safe use of art supplies and equipment.

Using the Lesson Plans

The lessons presented are intended to serve as suggested guides for the teacher. Each is concept-centered and integrates the four art disciplines of art production, art history, art criticism, and aesthetics. The focus of instruction is on the student's use of art concepts in analyzing, evaluating, and in making art, and in relating art concepts to culture and society.

Unit

Individual units are organized by the elements of art (line, value, texture, color, shape, form, and space) and principles of design (balance, emphasis, contrast, variety, rhythm, proportion, and unity). Additional units for art history, art criticism, and aesthetic judgment are included to provide specific additional focus.

Project

Projects within each unit are sequentially and cumulatively arranged and present a variety of techniques and media appropriate to the given art concept of the unit.

Objectives

Learning objectives are stated in behavioral terms, with behavioral outcomes linked to the visual concept being taught. Most lessons include objectives related to all four art disciplines of art production, art history, art criticism, and aesthetics. The integration of these four disciplines, with a combined emphasis on thinking, creating, perceiving, and feeling, allows for development in each lesson of objectives related to the cognitive, psychomotor, and affective domains. Information, concepts, and skills are learned in relation to specific works of art whenever possible.

Level

Scheduling of art in the middle school varies to such a degree that it is impractical to assign projects to a specific grade level. Courses may last nine, eighteen, or thirty-six weeks, may only be available to certain grades, or may contain students from mixed grades.

Though suggested grade levels are given for the sixth, seventh, and eighth grades, these correspond to beginning, intermediate, and advanced levels. This distinction may help the teacher in deciding which particular lesson is most appropriate for his or her students.

Materials & Preparation

Lists of materials and supplies needed for each lesson are suggested, along with tips for initial teacher preparation. Sources for unusual or specific material and supplies are given as needed.

The teacher needs to prepare an example of the project before presenting the lesson to the students, both for self-familiarization with the project and to have an example to present for motivation.

It is suggested that the teacher require and collect a student art fee to provide funds for sufficient materials and supplies and to allow for experimentation in a wide variety of media and techniques.

Instructional Resources

The integration of art production with art history, art criticism, and aesthetics requires that art concepts and skills be learned in relation to specific works of art. Art works utilized in the classroom should include the work of students and local and lesser-known artists as well as the work of famous artists. Art works used for resources should also include historical and multi-cultural works. All works of art used in the classroom should be chosen by the teacher according to their potential for extending and enlarging the perception of the students.

A wide variety of visual instructional resources should be presented to the students. Teacher- and student-made examples should be available whenever possible, along with prints and books. Other visual resources include slides, films, filmstrips, and videotapes. Check with the school library for possible resources or as a source for the largest selection of visual resources.

Even the most budget-conscious teacher can rely on slides for a visual resource. Though slides may be purchased from professional sources, copy slides may be made from books available at local and university libraries and at bookstores. Student work should also be photographed as slides for future use. The advantage of teacher-produced slides is that they can be created as needed and be relevant to the teacher's interests and needs.

Specific artists or works of art are suggested that relate to the concept of the lesson under **Instructional Resources**. Other suggestions include specific books, filmstrips, or videotapes.

Vocabulary

Vocabulary words and terms relevant to the concept of the lesson are identified.

Motivation/Guided Exploration

The teacher presents the concept of the lesson by utilizing visual resources, demonstration, modeling, guided discussion, and explanation as needed. Art works that relate to the given concept of the lesson should be examined and discussed. Students should also be given criteria for evaluation at this time.

Procedure

Detailed procedures are given for student practice of skills and techniques. Suggestions are made to the teacher for further extension or exploration of the project or concept.

Evaluation

Each lesson should end with student evaluations of the work of the class. Work should be displayed in the classroom and discussed in terms of lesson objectives and given criteria. Discussion can vary from individual to group, or may be verbal or written; employing a variety of means of evaluation throughout the course is suggested.

The teacher should evaluate student work for grading purposes in terms of lesson objectives. Criteria for evaluation are listed.

Time Allotment

A time allotment is not given for each lesson, as the time required to complete each varies widely according to the needs, interests, and abilities of individual students and classes.

UNIT:	
PROJECT:	**LEVEL:** ☐ 6th ☐ 7th ☐ 8th
OBJECTIVES	**PROCEDURE**
Students will	
MATERIALS & PREPARATION	
INSTRUCTIONAL RESOURCES	
VOCABULARY	
MOTIVATION/GUIDED EXPLORATION	**EVALUATION**
	Did students

Art Lessons for the Middle School

Public Relations for Art Education

Public relations covers all aspects involved in promoting art education in the schools. Positive publicity emphasizes the value of art education for all students; it contributes to increased recognition of art as a respected discipline within the schools; and it encourages administrative, parental, and public support for quality school art programs. Positive publicity also aids in student recruitment within the school and may lead to expansion of staff, facilities, and budget.

The art teacher is responsible for promoting the art program by arranging exhibition opportunities, organizing and presenting quality exhibits, and publicizing exhibits and events through publicity releases and photography.

Publicity Releases

There are many aspects to public relations, yet much of it simply involves getting information to the right place at the right time. The accepted form for the transmittal of information is called the **publicity** or **media release**.

Publicity releases are appropriate for newspapers, magazines, radio, and television; they can be written to publicize exhibits at school or in the community, contest entrants and winners, and art festivals and other special programs.

Type publicity releases doublespaced—on school letterhead, if possible—and include all pertinent data in a concise manner. Begin with a heading that includes the notice "FOR IMMEDIATE RELEASE," a short title, and the date. Follow the body of the release with the name and phone number of the person to contact for further information. Keep the release to one page and meet media deadlines, which vary from one to two weeks before publication. Call various media ahead of time to determine media contacts (such as art or education editors) and specific deadlines.

A bit of lagniappe delivered along with your publicity release may net more attention than a release alone. For a circus-themed art festival, send along a bag of popcorn or include a student-made Mardi Gras mask or paper sculpture crawfish to publicize a Louisiana theme. Sending photographs of students in the process of making art may attract an editor's attention. Be creative and inventive in publicizing exhibits and events. When your efforts result in good publicity, follow up with a note of thanks.

Public Relations in the School

There are many ways that art teachers can insure that the art program is highly visible within the school. Interesting exhibits of student work should be changed frequently on bulletin boards and in display cases. Showcase an Artist of the Month or the work of a specific class. If the school has no bulletin boards or display areas, ask for some. Mobiles can be hung in hallways, the office, or cafeteria. Students, teachers, administrators, and parents will notice and respond to art that is visible in the school.

Other possibilities for promoting art in the school include the sponsorship of an art club, maintaining an art program scrapbook, and presenting slide talks to the parent-teacher organization in the school.

Public Relations in the Community

The art program should also be promoted and publicized within the community. The teacher should arrange for exhibits of student work in local institutions such as banks, libraries, hospitals, malls, and art centers. Work for exhibits should be professionally presented, with all work matted and labeled with the student name. Include a sign with the school name, teacher name, and other pertinent information.

Publicize student entries and winners in competitions in the local media. Local hospitals, nursing homes, or similar institutions may also be adopted by the art club or classes for community service projects.

Art Exchange Programs

Opportunities exist for the exchange of student art work and goodwill on both the national and international level. For information, write:

1. Project Create or the International Child Art Exchange
 Box 237
 Yampa, CO 80483 (Send self-addressed, stamped envelope)

2. Paintbrush Diplomacy
 204 East 2nd Avenue, Suite 336
 San Mateo, CA 94401-9930

Other Organizations

The National Art Education Association and the Getty Center for Education in the Arts both promote art education in the schools and are invaluable for assistance and information on all aspects of art education.

1. National Art Education Association
 1916 Association Drive
 Reston, VA 22091

2. The Getty Center for Education in the Arts
 1875 Century Park East, Suite 2300
 Los Angeles, CA 90067-2561

Photography

There are times when photographs or slides are necessary for publicity, promotion, or student motivation. Every art teacher should have and be able to use a 35mm single lens reflex (SLR) camera. There are many totally automatic SLRs now available that make photography possible for all.

The art teacher will need to be able to take photographs or slides of student work for student motivation, portfolios or competitions, and to show students working for publicity or promotion purposes. Each of these situations requires specific methods.

To shoot two-dimensional art work for slides indoors in artificial light, set up the work on an easel or a wall with the work perpendicular to the floor. Set up two photofloods at least six feet away on either side of the art and position the camera on a tripod in front of the work. Use Ektachrome EPY 50 film and make exposure readings (with a light meter or the camera meter) on a photo gray card placed in front of the work. Try to fill the frame of the shot with the art work whenever possible, though corrections in framing can be made later, if necessary, on the actual slides with mylar photo masking tape.

Three-dimensional work may be photographed in the same manner, using a table top and a curved posterboard for background paper.

To take shots of students working in the classroom, use Ektachrome 100 and a camera flash (no subjects further than 15 feet away). Compose shots carefully and concentrate on close-ups of student's hands and faces. Shoot low or over the student's shoulder to get interesting shots of work in progress.

Slides of students working are great for student motivation and/or slide presentations to organizations. Tell a story or show the process of a project from start to finish in your slides. The regular use of photography in your classroom will be a tremendous aid in promotion and publicity, while also building your own slide library for future student motivation.

NOTE: Ektachrome EPY 50 and 100, photofloods, photo gray cards, and mylar photo masking tape may be found at photo supply stores.

Units

Each unit consists of a number of projects sequentially and cumulatively arranged (beginning, intermediate, advanced) and presents a variety of media and techniques appropriate to the given art concept of the unit.

The title page of each unit is designed so that it may be copied and distributed to students as a study guide.

Line

Value

Texture

Shape

Form

Space

Color

Balance

Rhythm and Movement

Proportion

Variety, Emphasis, and Unity

Art History

Art Criticism

Aesthetics

LINE

LINE: The path made by a moving point.

CONTOUR LINE: Line that defines and describes the edges and surface ridges of a shape.

GESTURE LINE: Quick, rough line that captures shape, form, and movement.

Line is one of the most important elements of art. It can be used to show the outline of a shape, to create texture, pattern, and value, and to suggest different moods. Lines can be straight, curved, thick, thin, long, short, rough, smooth, fuzzy, sharp, solid, broken, dark or light. Different kinds of art media can be used to draw different qualities of line.

There are five main kinds of lines, according to their directional path:
Vertical Horizontal Diagonal Curved Zigzag

 VERTICAL LINES move straight up and down and are perpendicular to the horizon.

 HORIZONTAL LINES are parallel to the horizon and give the impression of lying down.

 DIAGONAL LINES are slanted and appear to be either rising or falling.

 CURVED LINES change direction gradually to form curves, spirals, and circles.

 ZIGZAG LINES are diagonal lines that connect at points.

UNIT:	**LINE**				
PROJECT: INTRODUCTION TO LINE		**LEVEL:**	☑ 6th	☐ 7th	☐ 8th

OBJECTIVES

Students will

1. Identify five main kinds of lines.
2. Use five kinds of lines in a line chart.
3. Identify kinds of lines in examples of art and photography.
4. Evaluate student work.

MATERIALS & PREPARATION

- pencils
- smooth white drawing paper
- rulers

INSTRUCTIONAL RESOURCES

- Teacher-made line chart
- Slides of different kinds of lines evident in nature and in art work

VOCABULARY

line	diagonal
vertical	curved
horizontal	zigzag
perpendicular	

PROCEDURE

Students will create a line chart showing examples of the five main kinds of lines.

1. Divide drawing paper horizontally into five equal areas.
2. In the first area, draw five examples of vertical lines or images that appear vertical (flagpole, standing person, etc.)
3. In the second area, draw five examples of horizontal lines or images that appear horizontal (car, horizon, snake, swimmer).
4. In the third area, draw five examples of diagonal lines or images that appear diagonal (plane taking off, rain falling).
5. In the fourth area, draw five examples of curved lines or images that appear curved (snail, waves, curly hair).
6. In the fifth area, draw five examples of zigzag lines or images that appear zigzag (lightning, shark teeth).

NOTE:
The line chart may be varied by using only variations of non-representational lines. Variations of lines could include thick/thin, strong/weak, long/short, dark/light, continuous/broken.

7. Display and discuss finished line charts with students.

MOTIVATION/GUIDED EXPLORATION

Show and discuss with class slides of examples of five main kinds of lines:
1. Vertical
2. Horizontal
3. Diagonal
4. Curved (wiggly, spiral, circles)
5. Zigzag (connected diagonals)

Demonstrate method of dividing paper for line chart and draw variations of the kinds of lines for class.

EVALUATION

Did students
1. Illustrate five kinds of lines: vertical, horizontal, diagonal, curved, and zigzag?
2. Show variations of the five kinds of lines?
3. Evaluate own work?

UNIT:	**LINE**		
PROJECT: CONTOUR LINE DRAWING	**LEVEL:** ☑6th	☑7th	☑8th

OBJECTIVES

Students will
1. Identify lines, contours, and overlapping shapes.
2. Use line to create a contour drawing.
3. Identify art concepts in line drawings by artists and students.
4. Evaluate finished student work.

MATERIALS & PREPARATION

- pencils
- smooth white drawing paper
- erasers
- objects to draw (shoes, tools, hats, toys, etc.)

INSTRUCTIONAL RESOURCES

- Student line drawings
- Slide examples of line in art
- Suggested artists:
 Albrecht Dürer
 Vincent Van Gogh
 Alexander Calder
 Paul Klee

VOCABULARY

line	shape
contour	overlapping
edge	

MOTIVATION/GUIDED EXPLORATION

Show and discuss with class slides of examples of line.

Demonstrate ways to produce:
1. kinds of lines
2. qualities of line
3. expressive lines
4. lines describing an edge
5. overlapping lines and shapes

PROCEDURE

1. Present the following criteria for evaluation of completed art work:
 a. Kinds of lines:
 short/long, curved/straight, broken/continuous
 b. Qualities of lines: thick/thin, hard/soft, clean/fuzzy
 c. Expressive lines: straight/rigid, diagonal/exciting, horizontal/restful, vertical/dignified, undulating/energetic
 d. Lines that describe an edge
 e. Overlapping lines and shapes
2. Students observe object carefully and complete contour line drawing.
3. Students should draw lightly at first.
4. Drawing should fill the page as much as possible.
5. Display completed drawings and evaluate with class.

EXTENSION:
 Add value to drawing to create volume.

EVALUATION

Did students
1. Depict contours by means of line?
2. Use thick and thin, hard and soft lines?
3. Use three kinds of shapes: small, medium, and large?
4. Use overlapping shapes?
5. Express the character of the object represented?

UNIT:	**LINE**		
PROJECT: CALLIGRAPHIC BRUSH DRAWING		**LEVEL:** ☑6th ☑7th ☑8th	

OBJECTIVES

Students will

1. Recognize the expressive qualities of calligraphic line.
2. Use line to make calligraphic drawings with brush and ink.
3. Identify calligraphic line in Oriental art and calligraphy.
4. Evaluate finished work.

MATERIALS & PREPARATION

- pointed, round, small watercolor brushes
- white drawing paper, 12"x18"
- black and colored inks
- practice paper, 9"x12"
- containers for water
- paper towels for cleaning brushes

INSTRUCTIONAL RESOURCES

- Examples of calligraphic line in art work and calligraphy
- Related artists:
 - Shokado Shojo Mark Tobey
 - Katsushika Hokusai
 - Wu Zongyuan
 - Kathe Kollwitz

VOCABULARY

calligraphy: beautiful handwriting
calligraphic lines: flowing lines of varying width made with brush strokes similar to Oriental writing

PROCEDURE

1. Students draw a calligraphic study of a natural object (such as a flower, plant, leaf, or vegetable) or an arrangement of natural objects.
2. Students may use one or several colors of ink in the drawing.

NOTE:
Preliminary sketches may be made on practice paper to work out composition, but no pencil drawing should be made on final paper.

EXTENSION:
Use as introductory lesson to unit on calligraphy.

MOTIVATION/GUIDED EXPLORATION

Demonstrate correct use of brush. Hold loaded brush vertically and touch tip lightly to paper to make a line. Press brush down to make lines thicker; decrease pressure and pull brush up for thinner lines. Guide students through a page of practice strokes before beginning work on actual drawing.

EVALUATION

Did students
1. Use lines that vary in thickness and expressive quality?
2. Demonstrate control of the technique for creating thick and thin lines?
3. Use the principles of art in planning the composition?
4. Evaluate work?

UNIT:	**LINE**			
PROJECT: YARN PAINTING	**LEVEL:**	☑6th	☑7th	☑8th

OBJECTIVES

Students will

1. Identify line, texture, and color in yarn paintings.
2. Recognize yarn painting as a traditional Mexican craft form.
3. Design and create a yarn painting by gluing sets of parallel strands of yarn to cardboard.
4. Evaluate student work.

MATERIALS & PREPARATION

- yarn, various colors and textures
- pencils
- newsprint for practice paper
- corrugated cardboard or mat board, no larger than 8"x10", one per student
- scissors • toothpicks or paperclips
- glue

INSTRUCTIONAL RESOURCES

- Examples of yarn painting, Mexican or teacher-made
- **Art From Many Hands** by Jo Miles Schuman, pp. 150-153
- **ArtTalk**, by Rosalind Ragans, pp. 82-84

VOCABULARY

Mexican yarn painting
Huichol Indians
parallel

MOTIVATION/GUIDED EXPLORATION

Show examples of yarn painting and discuss traditional purposes for Huichol Indians of Mexico as religious tablets for votive offerings and to sell. Designs are usually based on natural subjects (animals, birds, plants, people), but are not realistic in color or form. Yarn paintings are traditionally done by men using beeswax instead of glue. Borders are completed first, then central figure, then background. Demonstrate procedures. Students may also choose abstract designs.

PROCEDURE

1. Students plan designs on practice paper, then transfer to cardboard.
2. Starting with border and one color of yarn, apply glue along edge and press yarn down into wet glue with toothpick or straightened paper clip. Keep toothpick clean so yarn will not stick to it.
3. Following same procedure, outline central figure with yarn, then fill in with other colors of yarn. Yarn should be applied to follow the contours of the figures that define each space, reducing the space with one continuous yarn until filled in. Cut yarn when area is filled. Put strands of yarn as close together as possible and fill from outer edges to center. Do not cross over adjacent strands of yarn to get to another area.
4. Fill in background when central figures are completed.
5. Abstract designs may not need to be worked in this specific order, but try to complete one area at a time.

NOTE:
Store work uncovered on a flat surface between work sessions to allow glue to dry undisturbed.

EVALUATION

Did students
1. Plan an original design using yarn as line?
2. Use a variety of patterns, textures, and colors?
3. Leave no cardboard visible between strands of yarn?
4. Use a minimum amount of glue to keep the work soft and free of visible glue?
5. Use sets of parallel yarn strands with no crossing of adjacent lines?
6. Evaluate student work?

UNIT: LINE

PROJECT: FOAMBOARD PRINTMAKING	LEVEL: ☑6th ☑7th ☑8th

OBJECTIVES

Students will

1. Identify different kinds of lines in prints.
2. Use line to create an edition of prints.
3. Recognize line in prints of artists and students.
4. Evaluate the use of line in artist and student work.

MATERIALS & PREPARATION

- newsprint, 6"x9" or 9"x12"
- pencils
- foamboard, 6"x9" or 9"x12"
- printing inks • masking tape
- brayers • newspaper
- printing trays • printing paper
- drying rack

INSTRUCTIONAL RESOURCES

- Teacher-made and student-made examples of foamboard prints
- Related artists:
 Edvard Munch
 Ben Shahn
 Paul Klee
 Clyde Connell

VOCABULARY

print	ink
edition	pull a print
printing plate	baren
brayer	artist's proof

MOTIVATION/GUIDED EXPLORATION

Show and discuss examples of prints
 that use line.
Demonstrate all steps of printing procedure
 before students begin to plan designs.
Show students that the finished print is a
 mirror image of the plate, and so any words
 must be drawn in reverse on the plate.
Demonstrate numbering, signing, and
 titling an edition.

PROCEDURE

1. Draw a design or image on newsprint that uses only line. Lines may be straight, curved, zigzag, expressive, or create pattern or texture, but should not be too close together or detailed. No shading should be attempted, as areas done this way will fill in with ink and ruin the print.
2. Tape the line drawing on the newsprint to the foamboard with masking tape. Trace over the line drawing lightly. This will transfer the image to the foamboard.
3. Remove the newsprint and trace again over the lines on the foamboard with a dull pencil. The lines need to be fairly deep and even in the foamboard to print well, but care should be taken not to cut through it with the pencil.
4. Place foamboard on a stack of cut newspaper. Squeeze ink on printing tray and roll brayer in ink to coat evenly.
5. Use ink-covered brayer to coat foamboard evenly. Roll in several directions and pay particular attention to edges of plate.
6. Place plate on clean piece of newspaper. Press printing paper right side down over plate and rub evenly with hands or baren.
7. Carefully pull off print; hang to dry. Repeat process for edition. Number and sign when dry.

EVALUATION

Did students
1. Use line to create a design or image in the print?
2. Use correct techniques to produce clean borders and crisp-edged lines?
3. Number, title, and sign edition?
4. Evaluate completed work?

UNIT: **LINE**

PROJECT: **WIRE SCULPTURE**	LEVEL: ☐ 6th ☑ 7th ☑ 8th

OBJECTIVES

Students will

1. Identify lines, contours, and overlapping lines.
2. Use line to form a wire sculpture.
3. Identify line in art work by Alexander Calder.
4. Evaluate student work.

MATERIALS & PREPARATION

- pencils
- wire cutters
- paper for practice drawings
- pliable colored wire
- monofilament line
- small wood blocks
- tempera or acrylic paints
- brushes

INSTRUCTIONAL RESOURCES

- Teacher- or student-made examples of wire sculptures
- Suggested slides: Wire sculptures & mobiles of Alexander Calder
- Suggested video:
 Mobile: Alexander Calder

VOCABULARY

sculpture	stabile
three-dimensional	
mobile	

PROCEDURE

1. Students make simple line drawings in pencil on practice paper to work out design ideas.
2. Using colored wire and various objects for bending, students form wire sculptures based on preliminary drawings.
3. Sculptures may be designed as mobiles or stabiles. Bases for stabiles may be painted as desired, and mobiles may be hung with monofilament line.
4. Display and evaluate finished works.

NOTE:
Wire may be obtained from art supply companies (check catalogs) or from the phone company (remainders of phone cable). The heavier wire from art supply companies works best, but the thin telephone wire may be more easily worked if it is first twisted together from two strands.

MOTIVATION/GUIDED EXPLORATION

Show and discuss examples of wire sculptures, slides, and/or video.
Demonstrate techniques for bending and working with wire, such as wrapping or bending on a pencil.
Discuss differences in mobiles and stabiles.

POSSIBLE MOTIVATIONS:
Figures, the circus, animals, machines, vehicles, portraits.

EVALUATION

Did students
1. Show use of line in sculptures?
2. Create well-conceived and competently executed designs?
3. Base the sculpture on original drawings?
4. Prepare work for display?

VALUE

VALUE: An element of art that refers to the degree of darkness or light.

VALUE SCALE: A chart that demonstrates the changing values of a tone on a scale of steps running from dark to light.

CHIAROSCURO: A method of arranging light and shadow to create the illusion of form: also called *shading* or *modeling*.

CROSSHATCHING: A technique of using crossed line for shading.

Nine-Step
VALUE SCALE

Shade with a lead pencil

Black

Low Dark

Dark

High Dark

Medium

Low Light

Light

High Light

White

Shade with a colored pencil

Darkest

Low Dark

Dark

High Dark

Medium

Low Light

Light

High Light

White (No color)

UNIT:	VALUE		
PROJECT: VALUE SCALE		**LEVEL:**	☑6th ☑7th ☐8th

OBJECTIVES

Students will

1. Distinguish changes in value.
2. Draw and shade in pencil a value scale with clearly contrasting values.
3. Recognize value as an element in works of art.
4. Evaluate historical, contemporary and student art work.

MATERIALS & PREPARATION

• white drawing paper 9"x12"
• pencils
• rulers
• optional: colored pencils

INSTRUCTIONAL RESOURCES

• Slides that illustrate value in artwork
• **ArtTalk** by Rosalind Ragans, pp. 81, 110-113
• **Drawing: Ideas, Materials, and Techniques** by Gerald Brommer
• Related artists:
 Albrecht Dürer Giotto M.C. Escher
 Caravaggio Rembrandt

VOCABULARY

value	chiaroscuro
value scale	crosshatching
shading	

MOTIVATION/GUIDED EXPLORATION

Display slides and examples of value and discuss with students how the three-dimensional quality of objects may be represented by a range of value differences.

Demonstrate procedures for drawing and shading a value scale.

PROCEDURE

1. With pencil and rule, draw a series of blocks or boxes (connecting or separated) down the paper. The number of blocks may vary from five to ten, but each should be the same size.

2. Use pencil to shade the boxes. The first should remain white. Each successive box should be shaded in a slightly darker value. There should be an obvious value change, from light to dark, through the succession of boxes.

ENRICHMENT:
1. Try using colored pencils instead of graphite. Create a color value chart.
2. Create a crosshatched value scale with pencil or pen and ink.
3. Divide a piece of drawing paper into areas with the 5 types of line. Subdivide further as described. Fill in areas with a range of different values.
4. Other media may also be used: ink wash, chalk, charcoal, tempera paint with black and white intermixed.

EVALUATION

Did students
1. Produce clearly distinguishable differences in value in the scales?
2. Discriminate value gradations in historical and contemporary artwork?
3. Evaluate completed work?

UNIT: VALUE

| PROJECT: VALUE DRAWING | LEVEL: ☑6th ☑7th ☑8th |

OBJECTIVES

Students will
1. Identify value in still life drawings.
2. Draw a still life arrangement that clearly exhibits contrasting value gradations.
3. Examine historical and contemporary still lifes.
4. Evaluate student work.

MATERIALS & PREPARATION

• newsprint • viewfinders
• drawing paper, white or colored
• pencils and/or colored pencils
• spray fixative
• still life setup or individual objects to draw
• optional: photoflood to cast strong shadows

INSTRUCTIONAL RESOURCES

• Slides and examples of still life drawings
• Related artists:
 Rembrandt William Harnett
 Leonardo da Vinci
• **Teaching Drawing from Art** by Brent Wilson, Al Hurwitz, & Marjorie Wilson
• **The Colored Pencil** & **Color Drawing Workshop** by Bet Borgeson

VOCABULARY

value	balance	chiaroscuro
still life	variety	modeling
shape	proportion	crosshatching
texture	color	

PROCEDURE

1. On newsprint, draw a number of thumbnail sketches in pencil to plan composition. Use viewfinders to aid in composition.
2. Lightly sketch contours of chosen composition on drawing paper, or draw first on newsprint, then transfer drawing with graphite. Draw large enough to fill the paper.
3. Complete drawing in chosen medium, producing strong contrasts in value.
4. Spray completed drawing with fixative (if appropriate for medium).

Other suggested media:
 Oil pastels Chalk
 Pen and Ink Crayons

ENRICHMENT:
• Use crosshatching techniques to obtain values in a composition.
• Juxtapose common and exotic objects in still life arrangement.
• Draw with white pencil on black or colored paper.

MOTIVATION/GUIDED EXPLORATION

Display and discuss examples of still lifes, both historical and contemporary.

Arrange a group of related objects for students to draw.
 Encourage students to discuss their texture, shape, color, and line, and possibilities for composition.

EVALUATION

Did students
1. Use variety, balance, and proportion in planning a composition?
2. Clearly show contrasting values in the drawing?
3. Evaluate completed work?

UNIT:	VALUE			
PROJECT: POINTILLISM		LEVEL:	☑6th ☑7th ☑8th	

OBJECTIVES

Students will

1. Identify value, line, and form, as evidenced in Pointillism.
2. Use markers in a pointillist technique to complete a drawing.
3. Recognize artworks of Pointillist style.
4. Critique artists' and student work.

MATERIALS & PREPARATION

• newsprint for sketching
• pencils
• white drawing paper
• fine point markers, black and/or assorted colors
• masking tape

INSTRUCTIONAL RESOURCES

• Related Artists:
 Georges Seurat Paul Signac
 Roy Lichtenstein
 Henri Matisse – "Luxe, Calm et Volupte´"
• Videotape:
 George Seurat: Point, Counterpoint

VOCABULARY

value	Neo-Impressionism
Pointillism	transfer
shade	optical mixing

PROCEDURE

1. Sketch line drawing of desired subject lightly in pencil on newsprint.
2. Transfer drawing to white drawing paper by shading back of newsprint with pencil lead. Tape newsprint to drawing paper (drawing side up) and trace over drawing with pencil to transfer. Remove tape and newsprint. Lines of drawing should be faintly visible on white paper.
3. Lightly dot with fine point marker along lines of drawing. Use dots to show character of line, value, and form. Place dots close together for darker values; further apart for lighter ones.
4. Drawings may be executed either in black or colors, or combined with line techniques. On color drawings, dots of colors may be mixed to create the appearance of other colors.

MOTIVATION/GUIDED EXPLORATION

Show and discuss with students the work of Seurat and Signac. Point out that Seurat originated the technique and spent more than a year on each painting.
Demonstrate how dots of color can be used to show value and to produce the appearance of other colors.
Relate Pointillism to the image on a color TV screen and to comic book printing techniques.

EVALUATION

Did students
1. Use marker-made dots to show value and form in a drawing?
2. Apply dots neatly and carefully?
3. Discuss and critique the work of Seurat?
4. Evaluate finished work?

UNIT:	**VALUE**		
PROJECT: WATERCOLOR PAINTING	**LEVEL:**	☐ 6th ☑ 7th	☑ 8th

OBJECTIVES

Students will

1. Identify value and color in watercolor painting.
2. Complete a watercolor painting.
3. Identify watercolor as a medium in historical and current art work.
4. Critique watercolor paintings.

MATERIALS & PREPARATION

- watercolor paper
- watercolor paints
- palettes
- containers for water
- paper towels
- pencils
- watercolor brushes, various sizes
- wooden drawing boards or corrugated cardboard covered with plastic
- masking tape or stapler & staples

INSTRUCTIONAL RESOURCES

- Slides of watercolors
- Related Artists:
 Winslow Homer Jigoku Soshi Qiu Ying
 Janet Fish Maurice Prendergast
- **Winslow Homer Watercolors** by Donelson F. Hoopes

VOCABULARY

watercolor	transparent
value	wash
luminosity	graded wash
glazing	lifting

MOTIVATION/GUIDED EXPLORATION

Show slides and examples of watercolors. Explain the need to work quickly, with freedom and spontaneity. Discuss the influence of the Impressionists on watercolor.

Demonstrate and explain watercolor techniques.

PROCEDURE

Prepare the paper:
Wet watercolor paper (the heavier, the better) on both sides under running water. Let excess drip off, then lay on board. Staple or tape wet paper to board. Let dry. Paper will stretch as it drys.

Painting
(If preliminary sketches are used, they should be transferred very lightly to the paper.)
1. Use clean, wet brush to wet area of paper to be painted.
2. Load brush carefully with color and apply paint to damp area, spreading quickly with brush as described. Colors should be mixed on the paper whenever possible. Complete painting by working large areas first. Dry brush details may be added when washes are dry.

NOTE:
The teacher may first guide students through a practice sheet of techniques.

1. wash
2. graded wash
3. variegated wash
4. glazing (mixing colors)
5. dry brush
6. wet on wet
7. wet on dry
8. lifting
9. spattering
10. resist
11. crayon resist
12. salt

EVALUATION

Did students
1. Stretch wet paper so that it dried taut and flat?
2. Apply graded washes to indicate value?
3. Mix colors on the paper?
4. Discuss and evaluate watercolor paintings?

TEXTURE

TEXTURE: The tactile quality of the surface of an object or material.

TYPES OF TEXTURE:

REAL OR ACTUAL TEXTURE: Texture that can be perceived through touch.

VISUAL OR IMPLIED TEXTURE: The two-dimensional illusion of a three-dimensional surface. There are two kinds — simulated and invented.

1. SIMULATED TEXTURE: The imitation of a real texture by using a two-dimensional pattern to create the illusion of a three-dimensional surface.

2. INVENTED TEXTURE: The creation of a texture by repeating lines and shapes in a two-dimensional pattern.

Texture is an element of art that refers to the way objects or surfaces feel or look like they feel. Texture can be rough or smooth, dull or shiny, hard or soft.

UNIT:	**TEXTURE**		

PROJECT: TEXTURE RUBBINGS (INTRODUCTION TO TEXTURE)	LEVEL:	☑6th	☐7th	☐8th

OBJECTIVES

Students will

1. Identify real and visual textures.
2. Illustrate different textures through texture rubbings and by drawing simulated and invented textures.
3. Recognize the use of texture in the work of a variety of artists.
4. Evaluate finished work.

MATERIALS & PREPARATION

- white drawing paper 12" x 18"
- pencils
- colored pencils or crayons with wrappers removed
- commercially made texture plates (available from art supply catalogs) or teacher-made texture plates (texture plates may be made by gluing textured materials to cardboard squares)

INSTRUCTIONAL RESOURCES

- Teacher-prepared slides on texture
- Variety of materials in different textures
- Hand-out on texture
- **ArtTalk** by Rosalind Ragans, pp. 175-203
- Related artists: Vincent Van Gogh
 Edgar Degas Bancusi Henry Moore
 Janet Fish I.M. Pei Max Ernst

VOCABULARY

texture rubbing
real (or actual) texture
visual (or implied) texture
simulated texture invented texture

MOTIVATION/GUIDED EXPLORATION

List and discuss the different kinds of textured surfaces in the room with the class. Pass around a variety of textured materials for the students to feel.

View and discuss slides.

Discuss real, visual, simulated, and invented textures.

Demonstrate method for texture rubbing, using side of pencil or crayon.

PROCEDURE

1. On the white paper, draw about nine shapes of different sizes. Have some shapes touch the edge of the paper. The result will resemble a simple jigsaw puzzle.
2. Place a texture plate under the paper and rub on the tip of the paper with the side of a pencil or crayon to fill the shape with the underlying texture. Repeat with different texture plates to fill about one-half of the shapes or spaces. Use a different color for each texture.
3. In the remaining shapes or spaces, use line patterns, stippling, and shading to create simulated and invented textures.

ENRICHMENT:
1. Texture rubbings can be cut out and rearranged into a collage.
2. Texture rubbings can be used to add detail to a drawing.
3. Complete a value drawing on textured paper.

EVALUATION

Did students
1. Make texture rubbings of a variety of textures?
2. Show both simulated and invented textures?
3. Evaluate completed work?

UNIT: **TEXTURE**				
PROJECT: CLAY TEXTURE TILES	**LEVEL:**	☑6th	☑7th	☑8th

OBJECTIVES

Students will

1. Identify different kinds of textured surfaces.
2. Experiment with the creation of real textures.
3. Design and make a textured ceramic clay tile using slab techniques.
4. Evaluate student work.

MATERIALS & PREPARATION

- drawing paper
- pencils
- scissors
- plastic bags
- water cups
- colored inks
- drinking straws
- brushes
- spray varnish
- wet ceramic clay
- assorted clay tools
- clay boards or burlap pieces
- wooden rolling pins (1 per table)
- assorted objects for creating textures (toothpicks, screws, etc.)
- Kiln
- glazes

INSTRUCTIONAL RESOURCES

- **ArtTalk** by Rosalind Ragans, pp. 175-203

VOCABULARY

clay	real texture
slab	wedge
bisque	

MOTIVATION/GUIDED EXPLORATION

Review characteristics and kinds of textures and discuss with students.

Show and discuss slide set on slab technique.

Demonstrate procedures for wedging clay and rolling out slabs of even thickness using slats and rolling pin.

PROCEDURE

1. Design shape and textural details of tile on paper in pencil. Cut out to use as pattern.
2. Roll out a slab of clay on clay board or burlap piece using rolling pin and two wooden slats.
3. Place pattern on clay and cut out with toothpick or needle tool.
4. Use a variety of clay tools and found objects to create textures on clay slab. Textures may be arranged in a pattern or design.
5. Use fingertips, tools, and a small amount of water to smooth edges and back of tile.
6. Use a drinking straw to push a hole into the top of the slab so the piece may be hung later.
7. Let dry when finished. (Work in progress should be stored in sealed plastic bag.) Fire in kiln when bone-dry.
8. Fired tiles may be painted with colored inks, then sprayed with gloss varnish when dry. Tiles could alternately be glazed and fired again.

ENRICHMENT:
Create Victorian or other architectural style house plaques.

EVALUATION

Did students

1. Experiment with a variety of textures using different tools and objects?
2. Roll out a clay slab of even thickness?
3. Smooth the edges and backs of tiles?
4. Plan a design utilizing the elements and principles of art?
5. Clean up the work space?
6. Evaluate finished work?

UNIT: **TEXTURE**	
PROJECT: SCRATCHBOARD	**LEVEL:** ☑6th ☑7th ☑8th

OBJECTIVES	**PROCEDURE**

OBJECTIVES

Students will

1. Recognize line as used to create simulated and invented texture.
2. Use a scratching tool to draw lines and textures on scratchboard.
3. Identify texture evident in the work of artists.
4. Evaluate student work.

MATERIALS & PREPARATION

- newsprint
- pencils
- scratchboards, pre-inked
- scratchboard pen points and holders or craft knives
- masking tape

INSTRUCTIONAL RESOURCES

- Finished scratchboard examples
- **How to Cut Drawings on Scratchboard** by Merritt Cutler
- **The Art of Scratchboard** by Cecile Curtis

VOCABULARY

scratchboard	hatching
real or actual texture	cross-hatching
simulated texture	invented texture
visual or implied texture	

PROCEDURE

1. Sketch the chosen subject in pencil on a piece of newsprint the same size as the scratchboard.
2. Shade back of drawing heavily with pencil lead. Tape drawing face-up to scratchboard and trace lightly with pencil. Remove newsprint from scratchboard.
3. Use scratching tool to lightly scratch along lines. Build lighter lines on areas by continued scratching, rather than by increased pressure. Scratching too hard will tear into the white areas of the board. Work with delicate lines whenever possible to create simulated or invented textures.
4. Display finished work.

ENRICHMENT:
 Watercolors may be used to selectively color in parts of the scratched design. Paint only in scratched lines or areas and wipe the surface lightly with a damp paper towel.

MOTIVATION/GUIDED EXPLORATION

Discuss with class types of texture subjects most suitable for scratchboard studies. Animals, plants, birds, and architectural subjects are all suitable.

Demonstrate procedures for transferring drawings to scratchboard and for using the scratching tool.

EVALUATION

Did students
1. Design a composition that makes adequate use of space?
2. Create a variety of textures appropriate to the chosen subject matter?
3. Use the scratching tool competently?
4. Evaluate finished work?

UNIT: TEXTURE

PROJECT: SIMPLE LOOM WEAVING	LEVEL: ☑6th ☑7th ☑8th

OBJECTIVES

Students will

1. Recognize line and texture in weaving.
2. Warp and weave on a simple (cardboard) loom.
3. Identify cultural and historical uses of weaving.
4. Evaluate finished woven work.

MATERIALS & PREPARATION

- cardboard looms - purchased or teacher-made (evenly spaced notches at top & bottom)
- strong cotton warp yarn
- variety of colors, textures, & thicknesses of yarn
- scissors • weaving needles
- plastic forks (optional)

INSTRUCTIONAL RESOURCES

- Examples of a variety of woven articles (fabric, wall hangings, belts, baskets, rugs).
- Slides of weaving and woven pieces from different cultures and time periods.
- **Weaving Without a Loom** by Sarita Rainey
- **Weaving–A Creative Approach for Beginners** by Clara Creager
- **Guatamelan Textiles Today** by Marilyn Anderson

VOCABULARY

weave	weaving needle	beat
weaving	warp	cartoon
loom	weft	weaver's knot
fiber	plain (tabby) weave	ends

MOTIVATION/GUIDED EXPLORATION

Show examples of a wide variety of types of weaving. Show slides and discuss with students the uses of weaving in primitive cultures and in contemporary society.

Present examples of various weights and textures of yarn.

Demonstrate procedures for warping loom and beginning and ending weaving.

PROCEDURE

TO WARP THE LOOM:
1. Tie a knot in one end of a long piece of cotton warp yarn and insert in the first slit from the edge of the loom; pull tightly.
2. Wrap yarn completely around the loom, inserting yarn in top and bottom slits in turn. Keep tension on yarn even and tight (though not enough to bend loom). When yarn runs out, tightly tie on a new piece and continue warping loom. When all slits are filled, tie off yarn at the end with a knot on the same side of loom as beginning knot. Weaving will be done on side of loom without knots.

TO WEAVE:
1. Thread a weaving needle with a piece of yarn about 20" long. Pull the yarn through the eye of the needle leaving a tail of about 6". Use no knots.
2. Hold loom so that warp yarns are vertical.
3. Weaving may begin at top or bottom of the loom. Weave the needle in and out of the warp across the loom, then pull the needle with the yarn through except for a short tail. Weave this tail back in with the fingers. Repeat process back and forth until complete, weaving in all ends. Change yarns as desired. Fill loom with weaving.
4. To remove weaving from the loom, cut warp yarns apart across the middle of the back of the loom. Remove two or three warp ends at a time from the loom; tie in a weaver's knot. Repeat till all ends of warp yarns are tied. Trim warp ends if desired (no shorter than 2").

EVALUATION

Did students
1. Warp the loom so that yarns were parallel and at even tension?
2. Weave yarns in an alternating, interlocking manner?
3. Keep the edges of the weaving straight and parallel to each other?
4. Have no yarn ends or knots visible in finished weaving?
5. Use a variety of textures and colors of yarn to make an interesting design?
6. Knot warp ends tightly with weaver's knots?

WEAVING

WEAVING: The process of interlacing yarns or fibers to make a fabric.

WARP: Parallel yarns held in tension and stretched lengthwise on a loom.

WEFT: Yarns which are interwoven into the warp.

FIBER: Slender, threadlike structure used for weaving; may be natural (wool, silk, cotton) or manufactured (acrylic, plastic, wire).

LOOM: A device or frame for weaving that supports the warp.

BEAT: To push new weft yarns in place against those already woven.

END: A single warp thread.

PLAIN or TABBY WEAVE: The simplest type of weave, in which the weft alternates going over and under the warp threads.

CARTOON: A drawing for the design of weaving.

CARDBOARD FRAME LOOM

CARDBOARD ROUND LOOM

HARNESS LEVERS

HARNESSES

BEATER

CASTLE

REED

BACK BEAM

BREAST BEAM

TABLE LOOM
(4 Harness Loom)

UNIT: **TEXTURE**	
PROJECT: LINOLEUM BLOCK PRINTING	**LEVEL:** ☐ 6th ☑ 7th ☑ 8th

OBJECTIVES	**PROCEDURE**
Students will 1. Recognize texture as an element of art. 2. Design and carve a linoleum block, and produce an edition of prints. 3. Recognize printmaking in exemplary works of art. 4. Critique prints.	1. On newsprint draw design for print in pencil. Transfer to linoleum block by shading back with pencil, taping face up on block, and tracing. 2. Using linoleum cutting tools, cut away the negative lines and spaces of the design. Cut away from body and keep fingers behind the cutting tool. (The linoleum board may be heated with an iron to facilitate cutting). Cuts must be deep enough and wide enough not to fill in with ink when printing. Leave in some textured detail; it is characteristic of linoleum prints. 3. To print, spread printing ink on a tray and roll brayer over it to coat evenly. 4. Place linoleum face up on stack of newspaper. Roll brayer over to coat surface. Remove newspaper layer underneath. 5. Center printing paper face down over block. Lay in place; rub back with hands, spoon, or baren. Pull off print; hang to dry. 6. Repeat process for remaining prints, re-inking for each new print. 7. Wash and dry block, brayer, and tray. 8. Number and sign all prints when dry.

MATERIALS & PREPARATION

- newsprint
- linoleum blocks
- pencils
- brayers
- printing inks
- linoleum carving tools
- inking trays or window glass with taped edges
- baren or spoon
- newspapers
- iron for heating linoleum (optional)
- printing paper

INSTRUCTIONAL RESOURCES

- **Relief Printmaking** by Gerald Brommer

VOCABULARY

print	texture
edition	line
brayer	relief
baren	

MOTIVATION/GUIDED EXPLORATION	**EVALUATION**
Show and discuss examples of different kinds of prints. Demonstrate all procedures for preparing the printing block and producing a print. Emphasize safety procedures and the need for caution with cutting tools.	Did students 1. Plan, design, and carve a linoleum block? 2. Produce an edition of numbered and signed prints? 3. Show evidence of understanding of the element and principles of art in completed print? 4. Produce prints with distinct edges and adequately inked surfaces? 5. Evaluate prints?

SHAPE

SHAPE: Element of art that is a two-dimensional area which is defined by an edge or outline.

TYPES OF SHAPES: Geometric (square, rectangle, circle, triangle, oval, rectangle, parallelogram, trapezoid, pentagon, pentagram, hexagon, and octagon) and free-form or organic (natural, irregular, uneven).

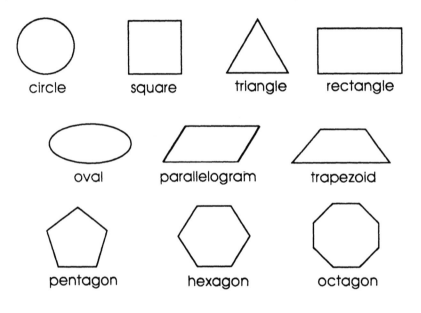

circle square triangle rectangle

oval parallelogram trapezoid

pentagon hexagon octagon

free-form

UNIT:	SHAPE		
PROJECT: POSITIVE & NEGATIVE CUT PAPER	LEVEL:	☑6th ☐7th ☐8th	

OBJECTIVES

Students will

1. Identify positive and negative shapes as elements of art.
2. Create a design from cut paper that exhibits positive and negative shapes.
3. Recognize positive and negative shapes in exemplary works of art.
4. Critique artworks that exhibit positive and negative space.

MATERIALS & PREPARATION

• construction paper, two different colors per student, one 9" x 12", one 6" x 9"
• pencils
• scissors
• glue

INSTRUCTIONAL RESOURCES

• *ArtTalk* by Rosalind Ragans, pp. 101-103

VOCABULARY

positive shapes
negative shapes

PROCEDURE

1. Using the 6"x9" paper, draw a line (angular, curved, or combination) that begins on one straight edge and ends on the opposite edge.

2. Cut apart carefully on drawn line.

shapes

3. Place pieces together on 9"x12" sheet. Flip right side of design over (top to bottom) and align straight edge with right side of paper.

4. Glue both pieces of paper in place.

EXTENSION:
1. Center a 4-1/2"x6" piece of colored construction paper on a 9"x12" sheet of different colored paper (use black and white or complementary colors). Lightly trace smaller sheet with pencil.
2. Cut out shapes from all four edges of the smaller sheet. Place shapes in reverse along the outside of the pencil lines and keep in order.
3. Glue down middle sheet, then glue cut out shapes in correct reversed place.

MOTIVATION/GUIDED EXPLORATION

Show and discuss with students examples of the use of positive and negative shapes in artwork.

Demonstrate procedures, then lead students through the process of cutting positive and negative shapes.

EVALUATION

Did students
1. Cut and glue paper to create a design that utilizes both positive and negative shapes?
2. Use materials and supplies correctly?
3. Evaluate completed work?

UNIT:	**SHAPE**		
PROJECT: COLLAGE	LEVEL:	☑6th ☑7th ☑8th	

OBJECTIVES

Students will

1. Identify shape as an element of art.
2. Cut geometric and free-form shapes from paper and use to create a collage.
3. Recognize collage as used in exemplary artworks.
4. Critique adult and student collages.

MATERIALS & PREPARATION

- pencils • scissors
- sturdy paper or board for background
- various colors and kinds of paper (construction, wallpaper, tissue, etc.)
- white glue or rubber cement
- found papers (optional)

INSTRUCTIONAL RESOURCES

- **The Art of Collage** by Gerald Brommer
- Related Artists:

 Max Ernst Juan Gris
 Romare Bearden Pablo Picasso
 Jean Arp Georges Braque
 Jean Dubuffet

VOCABULARY

collage	assemblage
shape	two-dimensional
geometric shape	overlap
free-form shape	composition

MOTIVATION/GUIDED EXPLORATION

Show slides or prints of collages and discuss with students.

Explain and demonstrate cutting of geometric and free-form shapes.

Demonstrate correct use and application of glue.

PROCEDURE

1. Cut and/or tear paper into desired shapes.
2. Arrange elements of the collage on the background paper to plan composition. Some shapes should overlap.
3. Glue shapes in place, using as little glue as possible.
4. Details may be added with found materials, marker, pencil, or ink.

SUGGESTIONS FOR SUBJECT MATTER:
1. Use primary colors, white and black, to create a non-objective collage using both geometric and free-form shapes.
2. Create a realistic collage of the school exterior, hallways, or classrooms.
3. Bicycles and riders.

EXTENSIONS:
1. Use different kinds and textures of papers to make a one-color collage.
2. Make a rubbing from the finished collage.

EVALUATION

Did students
1. Use both free-form and geometric shapes in collage?
2. Use a minimum amount of glue in collage?
3. Add detail to the collage?
4. Plan a balanced composition for the collage?
5. Evaluate completed work?

UNIT:	**SHAPE**		
PROJECT: COLLAGRAPH PRINTMAKING	**LEVEL:**	☑6th ☑7th ☑8th	

OBJECTIVES

Students will

1. Identify shape as an element of art.
2. Produce an edition of prints from a collage of low relief materials.
3. Recognize a collagraph as a print pulled from an inked collage.
4. Evaluate collagraph prints.

MATERIALS & PREPARATION

- scissors
- newspaper
- printing paper
- printing inks
- glue
- baren
- brayer
- cardboard or other heavy board for backing plate
- materials to cut for collage: papers, cardboard, foil, cloth, lace, yarn, found objects
- cheesecloth or other dauber

INSTRUCTIONAL RESOURCES

- **The Art of Collage** by Gerald Brommer, pp. 142–145

VOCABULARY

shape	relief
collagraph	free-form shapes
printmaking	geometric shapes
edition	baren

PROCEDURE

1. Cut and arrange papers and object on backing plate for collage.
2. Glue in place; let dry.
3. Ink with rolled cheesecloth or other dauber by rubbing printing ink completely over the surface and into the cracks and textures (or use brayer).
4. Wipe with clean cheesecloth or newspaper to remove excess ink.
5. Place inked plate face-up on a pad of newspapers.
6. Center printing paper face-down over plate and lay in position.
7. Rub back of print with hands, spoon, or baren.
8. Pull print off carefully; lay flat or hang to dry.
9. Repeat process for further prints, re-inking plate each time.
10. Number and sign completed edition of prints when dry.

EXTENSION:
Paint dry plate with one color acrylic paint. Display with print.

MOTIVATION/GUIDED EXPLORATION

Show examples of collagraphs and discuss with students.

Demonstrate all procedures for making printing plate, inking the plate, and pulling a print.

Demonstrate and explain procedure for signing and numbering prints.

EVALUATION

Did students

1. Use a variety of materials to construct a relief collage to be used for collagraph printing?
2. Follow procedures correctly to pull collagraph prints?
3. Clean up work area and materials at the end of each work session?
4. Evaluate completed work?

FORM

FORM: An object with three dimensions — length, width, and depth. Forms may be geometric or free-form. Geometric forms include the cone, cube, cylinder, and sphere.

UNIT:	**FORM**		

PROJECT: SEED and BEAN MASKS	LEVEL: ☑6th ☐7th ☐8th

OBJECTIVES

Students will

1. Perceive form, line, pattern, and symmetry in masks.
2. Manipulate beans and seeds to create a three-dimensional mask-like form.
3. Recognize the mask as an art form.
4. Critique masks from a variety of historical periods and cultures.

MATERIALS & PREPARATION

- pencils
- scissors
- glue
- spray gloss varnish
- poster board — black or colors
- newsprint or sketching paper
- large assortment of beans and seeds
- containers for beans and seeds

INSTRUCTIONAL RESOURCES

- Slides of a wide variety of masks from different cultures.
- **Maskmaking** by Carole Sivin
- **Masks of Black Africa** by Ladislas Segy

VOCABULARY

form
mask
pattern
symmetry

MOTIVATION/GUIDED EXPLORATION

View and discuss a variety of types of masks—especially African. Ask for examples of both functional and decorative contemporary masks. Discuss the use of exaggeration and stress pattern and symmetry in design.

Demonstrate procedures.

PROCEDURE

1. Fold newsprint in half and sketch in shape of mask and eyes, nose, and mouth. Cut out pattern and open up flat. Sketch design on mask.
2. Trace pattern on poster board and cut out.
3. Using a variety of beans and seeds, glue to mask, following planned design, to create patterns with line and shape. Place beans and seeds as close together as possible, so that little of the poster board shows through. Cover mask form completely. (Work should remain flat between work sessions to allow glue to dry.)
4. When glue is dry, spray with gloss varnish and display.

CONNECTIONS:
Compare masks of different cultures.

EVALUATION

Did students

1. Plan a symmetrical design using line and pattern?
2. Place beans and seeds close together with small amounts of glue?
3. Evaluate completed work?

UNIT:	**FORM**		
PROJECT: PAPER SCULPTURE	**LEVEL:**	☑6th ☑7th	☑8th

OBJECTIVES

Students will

1. Recognize forms as objects with three dimensions.
2. Make a three-dimensional paper sculpture by using cutting and scoring techniques.
3. Identify form in art work.
4. Evaluate form as an element of art.

MATERIALS & PREPARATION

- pencils
- glue
- rulers
- scissors and/or craft knife
- manila paper for experimentation
- tagboard, chart paper, or construction paper (white suggested)
- colored poster board for background paper

INSTRUCTIONAL RESOURCES

- Examples of scored and folded paper
- **ArtTalk** by Rosalind Ragans, p. 95-100
- "An Architectural Orientation to Paper," by Keith Stephens, <u>Arts & Activities</u>, Oct. 1987
- Related artists:
 - Moshe Safdie
 - LeCorbusier Eero Saarinen

VOCABULARY

shape	scoring (creasing)
form	paper sculpture
texture	three-dimensional
relief sculpture	

MOTIVATION/GUIDED EXPLORATION

Demonstrate differences between two-dimensional and three-dimensional paper shapes and forms.

Demonstrate methods for folding, cutting, and scoring paper. Neat, sharp folds are best made by scoring over lines or folds with a sharp object, taking care not to cut through the paper.

PROCEDURE

Practice folding and scoring techniques first with manila paper:

1. Accordion pleat design made from a series of parallel lines, scored alternately on opposite sides. Fold away from scored lines. This may be displayed horizontally or as a round column.
2. Cut into folds of accordion – folded paper with perpendicular or diagonal lines. Continue to score and fold on alternating sides.
3. Score paper on curved lines.
4. Add cutting to folding process.

After practicing techniques, execute final design in a heavy, stiff paper, such as tagboard. Completed forms may be free-standing, or mounted as relief sculpture on colored poster board.

EVALUATION

Did students
1. Use cutting and scoring techniques to make a three-dimensional paper sculpture?
2. Experiment with a variety of cutting and scoring techniques?
3. Prepare work for display?
4. Evaluate art works that exhibit form?

UNIT:	**FORM**		
PROJECT: PINCH POTS	**LEVEL:**	☑ 6th ☑ 7th ☑ 8th	

OBJECTIVES

Students will

1. Recognize the art elements of form and texture in the medium of clay.
2. Shape a clay pinch pot.
3. Identify pinch pot techniques in historical cultures.
4. Evaluate historical and student work.

MATERIALS & PREPARATION

- plastic bags
- clay tools
- red or white slips
- wet, wedged clay in handful-sized balls
- spoons for burnishing
- kiln
- Optional: small wooden or masonite boards
- burlap pieces
- water in containers

INSTRUCTIONAL RESOURCES

- Slides and examples of pinch pots
- **The Caddo Indians of Louisiana** by Clarence Webb and Hiram Gregory
- **Finding One's Way With Clay** by Paulus Berensohn
- **Clay Handbuilding** by Maurice Sapiro

VOCABULARY

form	texture
effigy	three-dimensional
Caddo Indians	

PROCEDURE

Distribute a ball of clay, a piece of burlap, and plastic bag to each student.

1. Using hands, roll clay into smooth ball.
2. Hold ball in both hands and press thumbs together down into center of clay.
3. Using thumbs on the inside and fingers on the outside, continue to press and turn clay to gradually increase the depth of the opening and to thin the walls of the pot. Dampen clay with water if it starts to crack.
4. Thin and shape walls of the pot until of uniform thickness. Lip of pot may be folded back, trimmed with a cutting tool, or smoothed with water.
5. Pots should be stored in plastic bags between working sessions.
6. Pots may be decorated by stamping with textures, polishing with spoon, incising with cutting tools, or painting with slip.
7. Let dry when complete, then fire in kiln.

EXTENSION:
A cardboard template may be cut to the desired outside shape and size of the pot and used as an aid to control the contour of the pot as it is formed.

MOTIVATION/GUIDED EXPLORATION

Show slides and examples of pinch and coil pots. Discuss with students pot design traditions of historical and contemporary Indians and of other cultures. Present examples of Caddo Indian designs and encourage students to suggest contemporary analogies. (Visit the Louisiana State Exhibit Building Caddo Indian Collection, if possible.)
Caddo Indian pottery was decorated primarily with incised curvilinear designs, such as spirals, concentric circles, and stylized serpents. Vessels included a diversity of form: bowls, bottles, jars, bird and turtle effigies, and tripod and tetrapod legs.
Demonstrate procedures with students.

EVALUATION

Did students
1. Hand build a clay pinch pot of original design?
2. Apply a decorative technique to the pinch pot?
3. Construct a pot with walls of even thickness?
4. Evaluate finished work?

UNIT: **FORM**	
PROJECT: CLAY HANDBUILDING	**LEVEL:** ☑6th ☑7th ☑8th

OBJECTIVES	PROCEDURE

OBJECTIVES

Students will

1. Identify elements and principles of art in clay forms.
2. Construct clay forms using a combination of clay handbuilding techniques.
3. Recognize clay as an art medium common to different historical periods and cultures.
4. Critique clay forms.

MATERIALS & PREPARATION

- wedged wet clay
- burlap pieces or canvas to cover tables
- clay tools • clay
- container of water and clay slip
- assorted objects for creating texture
- plastic bags for storing work
- kiln • glazes • brushes

INSTRUCTIONAL RESOURCES

- **Clay Handbuilding** by Maurice Sapiro

VOCABULARY

coil	form	glaze
slab	texture	model
pinch	fire	bone dry
slip	kiln	bisque
leather hard		

PROCEDURE

1. Students may use a variety of handbuilding techniques to construct a clay form:
 a. Pinching — pinch pots can be used as part of a form or combined to create a hollow round form.
 b. Slab — slabs of clay can be cut into shapes, textures, bent, shaped, combined with another form, or used as a base.
 c. Coil — may be used to build forms; may be smoothed with fingers or left as visible coils.
 d. Join forms with slip where needed. Dry work until bone dry, then fire in kiln. Glaze and refire if desired.

NOTE:
Between work sessions, keep work sealed in a plastic bag.

All forms to be fired must be hollowed out to prevent explosion when fired.

MOTIVATION/GUIDED EXPLORATION	EVALUATION

MOTIVATION/GUIDED EXPLORATION

Show slides and discuss with students. Review methods of clay handbuilding (coil, slab, pinch, modeling, carving).

Possible motivations:
 Animals, real or imaginary
 People Pop art subjects
 Gargoyles (common objects, food)
 Dinosaurs Architectural motifs

EVALUATION

Did students
1. Construct a clay form using a variety of handbuilding techniques?
2. Join clay coils to slab base and to each other by using correct joining techniques?
3. Clean up work area after each session?
4. Let clay forms to be fired in kiln dry sufficiently?

UNIT: **FORM**		
PROJECT: PAPIER-MÂCHÉ MASKS	**LEVEL:** ☑6th ☑7th ☑8th	

OBJECTIVES

Students will
1. Identify form, pattern, symmetry and design in masks.
2. Construct a three-dimensional papier-mâché mask of original design.
3. Recognize the mask as an art form used in historical and contemporary culture.
4. Evaluate masks from a variety of historical periods and cultures.

MATERIALS & PREPARATION

- sketching paper
- masking tape
- pencils
- paper towels
- tempera or acrylic paints
- newspaper, for masks and to cover table
- cardboard or mat board pieces
- papier-mâché paste, one container per table
- Optional: purchased mask forms
- scissors
- brushes
- found objects
- balloons

INSTRUCTIONAL RESOURCES

- Slides and examples of masks from a variety of cultures
- **Maskmaking** by Carole Sivin

VOCABULARY

form	papier-mâché (mashed paper)
pattern	three-dimensional
symmetry	

MOTIVATION/GUIDED EXPLORATION

View slides and examples and discuss with students possibilities inherent in the mask form. Masks can be functional or decorative, realistic or imaginary, and made of a variety of materials. Masks are often based on human or animal form and reflect spiritual and social concerns of the cultures that produced them.

Demonstrate procedures.

PROCEDURE

1. On sketching paper, plan design for mask in pencil.
2. Using newspaper, cardboard, masking tape, or balloons as needed, build form to support papier-mâché. Commercial mask forms may be altered by additions made from these materials.
3. Tear newspapers with the grain into pieces of various sizes. Dip one piece at a time into papier-mâché paste, wipe off excess with fingers, and spread over form. Cover form in the same method with overlapping pieces. Five to ten separate layers may be required for strength.
4. When layers are complete and mask is dry, remove carefully from underlying form.
5. Paint and decorate as desired.

ADDITIONAL:
- Construct masks with clay instead of papier-mâché.
- Study masks from different cultures and use as inspiration for designs (Mexican, African, Eskimo, Indian).

EVALUATION

Did students
1. Construct a three-dimensional mask of original design?
2. Use materials correctly?
3. Clean up work space after each class session?
4. Evaluate masks?

UNIT:	**FORM**			
PROJECT: MARDI GRAS SCREEN MASK	**LEVEL:**	☐ 6th	☑ 7th	☑ 8th

OBJECTIVES

Students will

1. Identify form, line, shape, and symmetry in screen masks.
2. Design and construct a screen mask.
3. Recognize masks from the screen mask tradition of southwest Louisiana Mardi Gras.
4. Critique both traditional and student-made screen masks.

MATERIALS & PREPARATION

- 8"x10" pieces of metal window screening (1 per student)
- pencils
- sketching paper
- elastic
- ball peen hammer
- double seam binding or strips of fabric
- hot glue gun
- oilpaint pens, assorted colors
- one 1"x10"x12" piece of pine, into which eyes, nose, and mouth have been cut

INSTRUCTIONAL RESOURCES

- **Maskmaking** by Carole Sivin

VOCABULARY

screen mask
Mardi Gras run (Courir de Mardi Gras)

PROCEDURE

1. On sketching paper, plan line design of mask in pencil.
2. Cut 3" slit in center bottom of pieces of screen.
3. Lay screen over wooden mold and carefully pound screening into the cutout contours of eyes, nose, and mouth.

screen

wooden mold

4. Remove screen from mold, overlap pieces of chin; hot glue in place.
5. Hot glue double seam binding or fabric around edges of mask to prevent the wearer from being scratched.
6. Referring to pencil design, use oil paint markers to draw the features of the face.
7. Attach elastic to mask and display.

ENRICHMENT:
 Make costumes in addition to masks and stage mock run. Research connections to Caribbean festivals.

MOTIVATION/GUIDED EXPLORATION

Discuss with students the screen mask and Mardi Gras traditions of the eight parishes in Southwest Louisiana. Masks are intended to conceal the identities of the riders on the "Mardi Gras Run," in which participants ride from farm to farm, provide entertainment, and collect ingredients for a community gumbo that is served at the end of the day. Riders wear masks with costumes and gloves.
Demonstrate procedures.

EVALUATION

Did students
1. Create an original design for a screen mask?
2. Follow procedures correctly?
3. Critique completed masks?

SPACE

SPACE: Element of art, in both two- and three-dimensional art, referring to the area within, around, between, above, or below object. *Positive spaces* (or figures) are the areas of a surface occupied by a shape or form; *negative spaces* (or ground) are the empty spaces within or surrounding the shapes or forms. Both positive and negative spaces may have a shape or form. Space may appear open, closed, deep, shallow, narrow, wide, or large.

PERSPECTIVE: The use of size variation, overlap, value, and converging lines to create the illusion of three-dimensional space (depth) on a two-dimensional surface.

UNIT:	**SPACE**		
PROJECT: ONE-POINT PERSPECTIVE	**LEVEL:**	☑6th ☑7th ☑8th	

OBJECTIVES

Students will

1. Identify perspective as the use of size variation and converging lines to create the illusion of 3-dimensional space on a 2-dimensional surface.
2. Complete a drawing using one-point perspective.
3. Recognize one-point perspective in exemplary artwork.
4. Evaluate the use of perspective in artwork.

MATERIALS & PREPARATION

- white drawing paper, 12"x18"
- pencils
- erasers
- rulers

INSTRUCTIONAL RESOURCES

- Related Artists:
 George Tooker—"The Subway"
 Raphael—"The School of Athens"
 Pietro Perugino—"The Delivery of the Keys"

VOCABULARY

plane	space
linear perspective	vantage point
vanishing point	
horizon (eye level)	

MOTIVATION/GUIDED EXPLORATION

Show and discuss slides/prints that show the use of one-point perspective.

Demonstrate the use of the horizon lines, vanishing points, and converging lines to create the illusion of depth.

PROCEDURE

1. With pencil and ruler, draw a horizontal line all the way across the paper at desired eye level.
2. Draw a dot for the vanishing point near the middle of the line.
3. Use the horizon line and the vanishing point to draw the inside area of a room.

POINTS TO REMEMBER:
a. The front edge or plane of each solid is parallel to the edge of the paper.
b. Top, side, and bottom edges of planes are drawn along lines that converge on the vanishing point.
c. Hidden edges of objects may be initially drawn with dotted lines.
d. Draw the intersecting lines needed, then develop lines for details. Erase perspective guidelines when no longer needed.

EVALUATION

Did students
1. Use one-point perspective to draw a portion of a room realistically?
2. Have appropriate lines converge on one vanishing point?
3. Draw all vertical lines parallel?
4. Critique perspective drawings?

UNIT: **SPACE**		
PROJECT: TWO-POINT PERSPECTIVE	**LEVEL:** ☐ 6th ☑ 7th ☑ 8th	

OBJECTIVES	PROCEDURE

OBJECTIVES

Students will

1. Identify perspective as the use of size variation and converging lines to create the illusion of 3-dimensional space on a 2-dimensional surface.
2. Complete a drawing using two-point perspective.
3. Recognize two-point perspective in exemplary artwork.
4. Evaluate the use of perspective in artwork.

MATERIALS & PREPARATION

- white drawing paper, 12"x18"
- pencils
- erasers
- rulers
- drawing boards, if available

INSTRUCTIONAL RESOURCES

- **Space** by Gerald Brommer

VOCABULARY

linear perspective plane
space
vanishing point
horizon (eye level)

MOTIVATION/GUIDED EXPLORATION

Show and discuss slides/prints that show the use of two-point perspective.

Demonstrate the use of a horizon line, two vanishing points, and converging lines to create the illusion of depth.

PROCEDURE

1. With pencil and ruler, draw a horizontal line all the way across the paper at desired eye level.

2. Draw a dot for each vanishing point on the horizon line at both edges of the paper.

3. Use horizon line and the two vanishing points to draw a building. Draw preliminary perspective lines, then develop details.

POINTS TO REMEMBER:
a. All vertical lines remain vertical.
b. Parallel lines seem to recede to the same vanishing point.
c. Both front and side planes seem to recede in depth.
d. Two-point perspective appears more similar to human vision than does one-point perspective.

EVALUATION

Did students
1. Use two-point perspective to draw a building realistically?
2. Have appropriate lines converge on two vanishing points?
3. Draw all vertical lines parallel?
4. Critique perspective drawings?

UNIT:	SPACE		

PROJECT: PAPYROTAMIA (POSITIVE AND NEGATIVE SPACE)	LEVEL: ☐ 6th ☑ 7th ☑ 8th

OBJECTIVES

Students will

1. Identify positive and negative space as elements of art.
2. Draw and cut out an elaborate, symmetrical cut paper design.
3. Recognize paper cutting as a decorative art form used by many cultures around the world.
4. Evaluate paper cuttings.

MATERIALS & PREPARATION

- newsprint or manila for practice
- brown craft paper or other colored thin, strong paper (12" x 18" or 16" x 22")
- colored or black paper or board for backing
- pencils • rulers
- scissors • craft knives
- glue • cardboard to cut on

INSTRUCTIONAL RESOURCES

- **Art from Many Hands** by Joe Miles Schuman, pp. 650-71, 154-156
- **The Paper Cut-out Design Book** by Ramona Jablonski

VOCABULARY

papyrotamia (decorative paper cutting)
symmetrical
positive and negative space

MOTIVATION/GUIDED EXPLORATION

Show and discuss paper cuttings from a variety of cultures: Mexican, Japanese, Chinese, Polish, etc. Demonstrate procedures for cutting on the fold, drawing borders, and planning designs.

Possible subject matter:
Animals Plants
Birds Sea life
People Imaginary deities

PROCEDURE

1. Fold practice paper in half with a vertical fold. Draw three parallel lines around edges away from fold.

 Fold

2. Divide the center space into three horizontal sections. The middle section should be larger.

3. Draw designs to fit within respective spaces. Plan a cutout for the middle of the three outside borders.

 Fold

4. Cut out designs on practice paper with scissors and craft knife. Open up paper.
5. Trace design on final paper (fold practice paper over folded final paper, matching folds).
6. Mark all negative spaces (those to be cut out) with an "X" to avoid mistakes when cutting.
7. Carefully use craft knives (cut over cardboard) to cut out spaces.
8. Open up completed work and glue to backing.

EXTENSION:
Colored tissue paper may be used for cutouts. Laminate over backing instead of using glue.

EVALUATION

Did students
1. Draw and correctly cut out a symmetrical design that utilizes both positive and negative space?
2. Cut clean edges and recognizable shapes with a craft knife?
3. Follow directions as given?
4. Critique completed cut paper designs?

UNIT:	**SPACE**			
PROJECT: TEMPERA RESIST PAINTING (POSITIVE AND NEGATIVE SPACE)	**LEVEL:**	☐ 6th	☑ 7th	☑ 8th

OBJECTIVES

Students will

1. Identify positive and negative space as elements of art.
2. Use tempera paint, glue, and ink to create a painting that utilizes positive and negative space.
3. Recognize positive and negative space in works of art.
4. Critique finished work.

MATERIALS & PREPARATION

- pencils • white glue
- brushes, stiff flat bristle
- newsprint (12" x 18" or 18" x 24")
- heavy watercolor paper (same size)
- mixing containers or palettes
- tempera paint – assorted colors
- black India ink (waterproof)
- access to large sink

INSTRUCTIONAL RESOURCES

- **ArtTalk** by Rosalind Ragans, pp. 101-103
- **Batik: The Arts & Crafts** by Kelier
- **Exploring Painting** by Gerald Brommer and Nancy Kinne
- **Space** by Gerald Brommer

VOCABULARY

resist	ink
batik	positive space
tempera paint	negative space

MOTIVATION/GUIDED EXPLORATION

Show and discuss with students examples of resist techniques such as batik. Explain the resist properties of a water-based ink and a nonsoluble mixture of tempera paint and glue. Demonstrate procedures.

Suggested subjects:

Architecture	Architectural details
Flowers	Still-life

PROCEDURE

1. In pencil, draw chosen subject with line on large piece of newsprint.
2. Transfer drawing to a large piece of heavy watercolor paper. (It is important that the paper be heavy enough to withstand extensive rinsing.)
3. Thickly paint the areas of the work to be colored with a mixture of half liquid tempera paint (positive space) and half glue. Colors may be mixed as desired with the glue in palettes or small cups, but only in amounts that will be needed for one sitting. Wash palettes, cups, and brushes thoroughly at the end of each session.
4. When painting, leave the lines of the drawing and any areas intended to be black unpainted (negative space). These areas of unpainted paper will absorb the black ink, while the painted areas will resist it. Let dry.
5. Paint with a thin coat of undiluted black ink.
6. Let dry completely, then rinse with cold water in a large sink. Using a large, soft brush, wet one painting at a time and rinse away ink from painted areas. Let dry on newspapers.

EVALUATION

Did students

1. Complete a tempera resist painting?
2. Use a mixture of half glue and half tempera to paint positive spaces?
3. Rinse work just enough to remove black ink from painted areas?
4. Evaluate completed work?

COLOR

COLOR: Element of art comprising hues produced through the reflection of light to the eye.

HUE: Pure color.

PRIMARY COLORS: Red, yellow, and blue pigments; pure colors from which other colors are mixed.

SECONDARY COLORS: Orange, green, and violet; obtained by mixing equal parts of two primary colors.

INTERMEDIATE COLORS: Red-orange, yellow-orange, red-violet, blue-violet, yellow-green, blue-green; obtained by mixing primary and secondary hues.

TINT: A light value of a hue; made by adding white.

SHADE: A dark value of a hue; made by adding black.

INTENSITY: The purity of a hue; may be bright, dull, or neutral.

COLOR SPECTRUM: Band of colors caused when a beam of light is passed through a prism.

COLOR WHEEL: A circle or wheel of colors, used by artists as a tool in organizing and understanding color.

COMPLEMENTARY COLORS: Colors that are opposite on the color wheel.

ANALOGOUS COLORS: Colors that are close together on the color wheel.

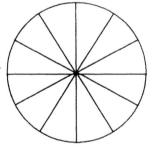

Twelve Step
Color Wheel

TRIADIC COLORS: Colors which form an equilateral triangle on the color wheel.

MONOCHROMATIC COLORS: Values or intensities of one color.

WARM COLORS: Hues that remind us of heat; red, yellow, orange.

COOL COLORS: Hues that remind us of cold; green, violet, blue.

UNIT:	**COLOR**		

PROJECT: COLOR WHEEL STUDY	LEVEL:	☑6th	☑7th	☑8th

OBJECTIVES

Students will

1. Identify color as an element of art.
2. Recognize and identify colors represented in the color wheel.
3. Use the primary colors to mix other colors.
4. Critique student work.

MATERIALS & PREPARATION

- white drawing paper, 12" x18"
- pencils
- brushes
- tempera paint – red, yellow, blue
- containers of water
- paper towels
- small jar lids or circle templates

INSTRUCTIONAL RESOURCES

- **The Elements of Color** by Johannes Itten
- **Color and Value** by Joseph Gatto

VOCABULARY

color	intermediate colors
hue	complementary colors
color wheel	analogous colors
primary colors	triadic colors
secondary colors	

PROCEDURE

1. Use template to trace circles for colors in color wheel. Start with three circles in a triangular formation for the three primary colors. Connect with straight lines.

2. Add a circle halfway between each for the secondary colors. Connect with dotted lines.

3. Add a circle between each of these for the intermediate colors. There will be twelve circles.

4. Use the primary colors of paint—red, yellow, and blue—to mix colors needed and paint color wheel.

OTHER POSSIBILITIES.
1. Draw color wheel by dividing a circle into 12 pie-shaped wedges.
2. Plan a creative design or image that incorporates the concepts of the color wheel.

MOTIVATION/GUIDED EXPLORATION

Show and discuss slides or prints that illustrate color theory. Discuss primary, secondary, intermediate, and complementary colors.

Present examples of completed color wheels and discuss color theory.

Lead students through steps involved in drawing color wheel.

EVALUATION

Did students
1. Use the primary colors to mix the other colors in the color wheel?
2. Place colors in correct sequence on the color wheel?
3. Paint colors so that there is a discernible difference in adjacent circles?
4. Evaluate completed color wheels?

UNIT: COLOR

PROJECT: COLOR VALUE STUDY **LEVEL:** ☑ 6th ☑ 7th ☑ 8th

OBJECTIVES

Students will

1. Recognize color as an element of art.
2. Paint a color value study.
3. Identify value and color in exemplary works of art.
4. Evaluate completed color value studies.

MATERIALS & PREPARATION

• white drawing paper, 12"x18"
• pencils • brushes
• rulers (optional)
• tempera paint: black, white, red, yellow, blue
• containers of water
• paper towels

INSTRUCTIONAL RESOURCES

• **The Elements of Color** by Johannes Itten

VOCABULARY

color tint
hue shade
value
value scale (or chart)

PROCEDURE

1. With pencil (and ruler if desired) draw three evenly spaced nine-step value scales.

2. The middle section of each value scale should be painted a pure hue.

3. Add increasing amounts of black to each hue going up the scale.

4. Add increasing amounts of white to each hue going down the scale.

5. The three completed scales will show each primary color in a value scale of tints and shades.

MOTIVATION/GUIDED EXPLORATION

Show and discuss slides/prints that illustrate values of color. Discuss tints and shades.

Present examples of completed color value scales and discuss.

Lead students through steps involved in drawing color value scales.

EVALUATION

Did students
1. Use black, white, red, yellow, and blue paint to create three color value scales?
2. Mix and paint colors so that a discernible difference in value is apparent on each color value scale?
3. Critique completed work?

UNIT:	**COLOR**			
PROJECT: PAINTING WITH SPECIFIC MOTIVATION	**LEVEL:**	☑6th	☑7th	☑8th

OBJECTIVES

Students will

1. Identify color as an element of art.
2. Use color as an expressive element in artwork.
3. Recognize the expressive qualities of color that artists use to create meaning.
4. Evaluate the use of color in paintings.

MATERIALS & PREPARATION

- white drawing paper or other painting surface
- pencils
- brushes
- tempera paints
- containers of water
- paper towels

INSTRUCTIONAL RESOURCES

- Related Artists:
 Andre Derain
 Henri Matisse
 Raoul Duffy
 Georges Roualt
 Maurice Vlaminck

VOCABULARY

hue
Fauves
tempera

PROCEDURE

Use tempera paint to complete painting of desired subject.

POSSIBLE IDEAS FOR PAINTINGS:
1. Monochromatic color scheme.
2. Complementary color schemes.
3. Analogous color schemes.
4. Paint the same subject twice — once in cool colors, once in warm colors.
5. Use as motivation a "colorful phrase," such as "tickled pink," "seeing red," "feeling blue," etc.
6. Paint the same subject 4 different ways: (1) realistic color, (2) complementary colors, (3) monochromatic color, (4) black, white, gray.
7. Paint on colored paper.
8. Use heavy crayon lines as resist to outline shapes; then paint.
9. Pre-draw design in pencil.
10. Paint directly without pre-drawing.

MOTIVATION/GUIDED EXPLORATION

Show and discuss slides/prints of artworks that exhibit the expressive qualities of color. (The group of artists known as the Fauves would be appropriate to a discussion of color.)

Discuss possible motivations with students.

Encourage students to paint large areas first, then to add sufficient detail.

EVALUATION

Did students
1. Exhibit proficiency in painting techniques?
2. Clean up work area and supplies after each work session?
3. Use color as an expressive element?
4. Critique completed paintings?

BALANCE

BALANCE: Principle of design concerned with the arrangement of the elements of a composition. Three types of balance are symmetrical (formal), asymmetrical (informal), and radial.

SYMMETRICAL BALANCE: Type of balance in which two halves of a design are identical, mirror images of each other.

ASYMMETRICAL BALANCE: Type of balance in which the elements of a composition have equal visual weight.

RADIAL SYMMETRY or BALANCE: Variation of symmetrical balance, in which all elements of a composition converge on a central point or axis.

UNIT: **BALANCE**

PROJECT: **PAPER CUTOUTS** (SYMMETRICAL BALANCE)	LEVEL: ☑ 6th ☑ 7th ☑ 8th

OBJECTIVES

Students will

1. Identify symmetrical balance as a principle of design.
2. Design and make a symmetrical paper cutout.
3. Recognize symmetrical balance in exemplary works of art, both historical and multicultural.
4. Evaluate symmetry in works of art.

MATERIALS & PREPARATION

- pencils
- scissors
- newsprint for practice
- iron (optional)
- hole punch (optional)
- brown craft paper or any strong, thin paper (assorted colors also)
- assorted colors construction paper for backing
- white glue or rubber cement

INSTRUCTIONAL RESOURCES

- **Art From Many Hands** by Jo Miles Schuman
- **Balance and Unity** by George Horn
- **Design Motifs of Ancient Mexico** by Jorge Encisco
- Multicultural Resources:
 Polish Wycinanki Amate paper cutouts
 Chinese paper cutouts

VOCABULARY

symmetrical (or formal) balance
central axis
mirror image
bilateral symmetry

PROCEDURE

1. Fold practice paper in half. Using the fold as a center line, lightly draw with pencil half the form of a bird, animal, person, or other intricate shape. Cut out while folded. Open up the design.
2. Refold and trace or redraw on folded final paper. Cut out carefully. If using brown craft paper, crumple thoroughly, carefully spread it open again, then iron flat. (Crumpled paper mimics appearance of Mexican Amate paper.)

3. Glue cutout to center of solid color sheet of backing paper.

EXTENSION:
- Hole punch or linoleum cutting tools may be used to cut shapes from folded design.
- Brown craft paper may be ironed between two sheets of waxed paper to create a different texture.

MOTIVATION/GUIDED EXPLORATION

Present examples of appropriate artworks that illustrate symmetrical (formal) balance. Symmetrical balance creates an effect of dignity, calm and stability. Human bodies are symmetrical, as is much architecture. Many living creatures display bilateral symmetry.

Demonstrate procedures for drawing and cutting on the fold.

EVALUATION

Did students
1. Draw and cut correctly on the fold?
2. Design and make a symmetrical paper cutout?
3. Evaluate works of art that exhibit symmetrical balance?
4. Evaluate completed work?

UNIT:	**BALANCE**	
PROJECT: KALEIDOSCOPE DESIGN	**LEVEL:**	☑ 6th ☑ 7th ☑ 8th

OBJECTIVES

Students will

1. Recognize radial symmetry in natural and manufactured objects.
2. Create a repeating kaleidoscope design.
3. Identify radial symmetry in the work of M.C. Escher.
4. Critique artwork that exhibits radial symmetry.

MATERIALS & PREPARATION

- 9" circle templates
- pencils • scissors
- newsprint or other sketching paper
- colored markers or pencils
- white drawing paper
- masking tape
- 1/4 or 1/6 circle templates

INSTRUCTIONAL RESOURCES

- A child's kaleidoscope
- Slides of objects that exhibit radial symmetry
- **The World of M. C. Escher** by M. C. Escher and J. C. Locher
- **Kaleidoscope Designs and How to Create Them** by Norma and Leslie Finkel

VOCABULARY

symmetry
radial symmetry or balance
kaleidoscope
mandala (concentric organization of geometric shapes)

PROCEDURE

1. On sketching paper, trace wedge-shaped template for 1/4 or 1/6 of circle.
2. With pencil, draw line, pattern, or texture design that fills the space. Intricate designs work best when repeated in the circular fashion of the kaleidoscope.
3. Shade the back of the wedge with pencil, then cut out.
4. Trace circle template on desired surface. Align the design wedge in the circle and tape in place. Trace design in pencil to transfer. Repeat by moving wedge and tracing image until circle is complete.
5. Color in one wedge at a time, repeating same colors, values, and textures in each wedge.

ENRICHMENT:
1. Incorporate student name into design and use on cover of art portfolio.
2. Draw design in newsprint, transfer to clay slab, cut out and decorate with lines and textures using clay tools. Fire and glaze or paint.
3. Execute design in fabric applique.

MOTIVATION/GUIDED EXPLORATION

Discuss radial symmetry in which the elements of a design appear to radiate from a central point. This type of design is apparent in kaleidoscopes or mandalas. Ask for student examples from nature (flowers, snowflakes) and man-made objects that display radial symmetry (kaleidoscope, wheel, clock). Pass around kaleidoscope for viewing if available. Demonstrate procedures for planning a design of radial symmetry.

EVALUATION

Did students
1. Plan an intricate design that repeats to form a kaleidoscope effect?
2. Align wedge designs carefully to create a design that works as a whole unit?
3. Repeat the same design in the same way in each wedge?
4. Evaluate kaleidoscope designs?

UNIT:	**BALANCE**	
PROJECT: ROUND WEAVING (RADIAL SYMMETRY)	LEVEL:	☑6th ☑7th ☑8th

OBJECTIVES

Students will

1. Recognize radial symmetry in natural and manufactured objects.
2. Use yarn to create a round weaving.
3. Identify radial symmetry in works of art.
4. Critique completed weavings.

MATERIALS & PREPARATION

- scissors
- tape
- pencils
- weaving needles (optional)
- round heavy cardboard circles (8" pizza boards work well)
- variety of thicknesses and textures of yarn for weft
- cotton warp yarn

INSTRUCTIONAL RESOURCES

- **Weaving Without a Loom** by Sarita Rainey
- **Balance and Unity** by George Horn

VOCABULARY

loom	warp
kaleidoscope	weaving
mandala	weaving needle
weft	radial symmetry or balance

PROCEDURE

1. Cut an <u>odd</u> number (11 or 13) of evenly spaced notches around the edge of a cardboard circle. Punch a hole in the center with a pencil.
2. Cut a long cotton warp and thread through weaving needle leaving a short tail.
3. Tape the end of the yarn to the back of the loom and bring the threaded needle up through the center hole. Wrap the yarn around the loom by catching the yarn in a notch, going back around the loom and back up through the center hole. Continue till warp is complete. Tape all ends on back.
4. To weave, thread needle as above with desired yarn (about 18" long). Start in center of front of loom, weaving over and under one yarn at a time, about half-way around the loom. Pull yarn through except for a very short tail. Continue till completed. Yarn ends may be woven in or cut off.

MOTIVATION/GUIDED EXPLORATION

Discuss radial symmetry in which the elements of a design appear to radiate from a central point. Ask for student examples of natural and manufactured objects that display radial symmetry.

Demonstrate procedures for warping loom and weaving weft.

EVALUATION

Did students
1. Create a radial weaving?
2. Weave in an over-and-under pattern?
3. Leave no warp ends showing?
4. Plan a design with appropriate textures and colors?
5. Evaluate finished work?

UNIT:	**BALANCE**		

PROJECT: DESIGNS THAT GROW (ASYMMETRICAL BALANCE) **LEVEL:** ☑ 6th ☑ 7th ☑ 8th

OBJECTIVES

Students will

1. Identify asymmetrical balance as a principle of design.
2. Cut out and glue together an asymmetrical design using two colors of paper.
3. Recognize asymmetrical balance in exemplary works of art.
4. Critique artworks that exhibit asymmetrical balance.

MATERIALS & PREPARATION

- 2 pieces of construction paper in contrasting colors for each student
- pencils
- scissors
- white glue

INSTRUCTIONAL RESOURCES

- **Design Activities for the Classroom** by John Lidstone, pp. 90-91
- **Balance and Unity** by George Horn

VOCABULARY

asymmetrical (or informal) balance
visual weight
negative and positive shapes

MOTIVATION/GUIDED EXPLORATION

Present examples of appropriate artworks to illustrate visual weight in asymmetrical balance. The balancing of visual weight in asymmetrical compositions creates a casual effect and may be attained through size, color, value, texture, or position. Show and discuss each example.

PROCEDURE

1. Each student receives two pieces of paper in contrasting colors. On one sheet, cut off a border of one-half inch on each side. The large sheet will be the base.
2. Geometric and/or free-form shapes are cut from the smaller sheets.
3. These shapes are moved out in all directions on the larger sheet to create an asymmetrical composition that fills the area of the larger sheet.
4. Cut larger shapes first, then cut smaller shapes to fill out the composition. The negative spaces created by the bottom sheet should be considered as part of the design.
5. When all shapes are cut and satisfactorily arranged into an asymmetrical design, glue them into place.

EXTENSION:
Use complementary colors for the two sheets of paper.

EVALUATION

Did students
1. Cut and glue an asymmetrical design that has balanced visual weight?
2. Utilize both positive and negative shapes in the design?
3. Glue shapes carefully and neatly in place?
4. Evaluate work showing asymmetrical balance?

RHYTHM AND MOVEMENT

RHYTHM: Principle of design that repeats elements to create the suggestion of movement. Rhythm may be random, regular, alternating, flowing, or progressive.

PATTERN: Two-dimensional repetition of a motif.

MOVEMENT: Principle of design in which the eye of the viewer is directed from one element to another, creating the suggestion of movement or action.

UNIT:	**RHYTHM AND MOVEMENT**		
PROJECT: PAPER WEAVING	**LEVEL:**	☑ 6th ☐ 7th ☐ 8th	

OBJECTIVES

Students will

1. Identify rhythm as a principle of design that repeats elements to create the illusion of movement.
2. Create a paper weaving using a repeating pattern.
3. Recognize weaving as used culturally and historically.
4. Evaluate weavings.

MATERIALS & PREPARATION

- construction paper, 9"x12"
 - two per student of two different colors
- pencils
- scissors
- glue
- rulers

INSTRUCTIONAL RESOURCES

- Examples of weaving: paper, yarn, etc.
- **Weaving Without a Loom** by Sarita Rainey

VOCABULARY

weaving	plain weave (tabby)
loom	repetition
warp	
weft	

PROCEDURE

Each student needs two contrasting color pieces of paper, pencil, ruler, and scissors.

1. Fold one of the papers in half (each half will measure 6"x9"). With ruler on open end of folded paper, mark off a 1" strip.

2. With paper still folded, draw parallel lines down from the horizontal line to the fold. Lines may be straight, zigzag, wavy, or a combination. Draw lines at least 1" apart.

3. Cut on lines up to horizontal line. Open up flat. This is the paper loom. These strips form the warp.

4. On second sheet of paper, draw parallel lines across the width of the paper. Cut strips apart and realign on table. These will form the weft.

5. Weave weft strips into warp, over and under, in the order in which they were cut. Push close together.

6. Weave in as many strips as possible. Trim any overhanging strips. Glue down ends on both sides.

MOTIVATION/GUIDED EXPLORATION

Show and discuss examples of weavings that illustrate rhythm and pattern. Discuss historical and cultural uses of weaving.

Demonstrate procedures, then lead students through steps of the activity.

EVALUATION

Did students
1. Create a paper weaving that shows rhythm and repetition of pattern?
2. Alternate warp and weft to form an interlocking weaving?
3. Critique weavings?

UNIT:	**RHYTHM AND MOVEMENT**				
PROJECT: CLAY COIL CONSTRUCTION		**LEVEL:**	☑6th	☑7th	☑8th

OBJECTIVES	PROCEDURE

OBJECTIVES

Students will

1. Identify rhythm as a principle of design that indicates movement by the repetition of elements.
2. Use clay coils to construct a pot with rhythmic qualities.
3. Recognize rhythm and the use of repetition in exemplary artworks.
4. Critique clay coil constructions.

MATERIALS & PREPARATION

- wet, workable clay
- clay modeling tools
- containers of water
- burlap pieces or boards
- plastic bags for work storage
- kiln • brushes
- glazes • clay slip

INSTRUCTIONAL RESOURCES

- **ArtTalk** by Rosalind Ragans, pp. 211–241

VOCABULARY

rhythm	glaze
movement	fire
clay	kiln
coil	

PROCEDURE

1. Assemble all supplies needed: clay, burlap or board for work surface, water, slip, clay tools.
2. Make a base for the pot by flattening a small piece of clay into a circle (or other shape) or by connecting coils of clay.
3. Shape clay coils by rolling small balls of clay into rolls of consistent diameter. Keep hands damp and work on a burlap or board surface.
4. To join coils, cut the ends on a diagonal and join them so that the seam does not show. Dampen with slip if necessary.
5. Attach coils to base and add new coils to outer edge of previous coils. Use fingers to smooth out seams. Leave coils showing on either outside or inside of pot. Leave some or all of the seams showing to emphasize the rhythmic quality of the pot.
6. Continue adding coils to form desired shape of pot.
7. In between work sessions, store in plastic bag.
8. When completed, let dry. Fire, glaze, and refire.

MOTIVATION/GUIDED EXPLORATION	EVALUATION

MOTIVATION/GUIDED EXPLORATION

Show and discuss examples of artwork that use repetition to suggest movement.

Demonstrate all procedures for working with clay.

EVALUATION

Did students
1. Construct a pot (or other object) with rhythmic qualities by joining clay coils?
2. Use correct joining procedures?
3. Allow some or all of the coils to show?
4. Evaluate completed work?

UNIT:	**RHYTHM AND MOVEMENT**		

PROJECT: TRANSFORMATIONS (PROGRESSIVE RHYTHM) **LEVEL:** ☑ 6th ☑ 7th ☑ 8th

OBJECTIVES

Students will

1. Identify rhythm as a principle of design that indicates movement by the repetition of elements.
2. Complete a sequence of drawings in which one motif is transformed into another through progressive change.
3. Recognize rhythm in artworks.
4. Critique the use of rhythm in artworks.

MATERIALS & PREPARATION

- white drawing paper
- rulers
- pencils
- colored pencils or markers

INSTRUCTIONAL RESOURCES

- **ArtTalk** by Rosalind Ragans, pp. 211-241
- "Dynamism of a Dog on a Leash" by Giacomo Balla
- "Nude Descending a Staircase" by Marcel Duchamp
- "Red Cross Train" by Gino Severini

VOCABULARY

rhythm	repetition
motif	Futurism
movement	
progressive movement	

MOTIVATION/GUIDED EXPLORATION

Show examples (such as the work of the Futurists) of the use of rhythm in artwork and discuss.

Discuss choosing a motif and transforming it by changing size, value, color, and detail to show progression.

Demonstrate procedures.

PROCEDURE

1. Choose a simple motif—an ordinary object, an animal, or a person. Think of a likely resulting motif for the transformation process. The two motifs may be either visually or conceptually connected. (Examples: seed into flower, cocoon into butterfly, banana into airplane, bicycle into sunglasses.)
2. With ruler and pencil, divide paper into desired size and number (5-12) of connecting blocks.

or

3. Draw chosen motif in first block. Proceed with drawings in successive blocks, creating a progressive rhythm by gradually changing the first motif into the resulting motif, through the use of detail, size, color, or value.
4. Use colored pencil or marker to complete drawing.

EVALUATION

Did students

1. Create a series of drawings that show progressive change and rhythm?
2. Use color to enhance the rhythmic quality of the work?
3. Evaluate completed transformations?

UNIT:	**RHYTHM AND MOVEMENT**		
PROJECT: MARBLED PAPER PAINTING		**LEVEL:** ☐ 6th ☑ 7th ☑ 8th	

OBJECTIVES

Students will

1. Identify rhythm as a principle of design that repeats elements to create the illusion of movement.
2. Marble the surface of a paper and then paint on the marbled paper.
3. Recognize marbling as a decorative art technique.
4. Evaluate works that exhibit marbling.

MATERIALS & PREPARATION

- brushes
- pencils
- acrylic paints
- wide-toothed comb, nail
- construction paper in various colors (12"x18")
- flat plastic pan, large enough to hold paper (with lid)
- undiluted liquid laundry starch
- containers for water and paint
- newsprint (12"x18")

INSTRUCTIONAL RESOURCES

- **ArtTalk** by Rosalind Ragans, pp. 211-241
- **Movement and Rhythm** by Gerald Brommer

VOCABULARY

rhythm	paper marbling
movement	acrylic paint
repetition	
pattern	

MOTIVATION/GUIDED EXPLORATION

Discuss with students the use of paper marbling as a decorative art.

Demonstrate all procedures.

PROCEDURE

1. Dilute acrylic paint with water to the consistency of cream.
2. Fill a large flat pan almost 2" deep with liquid starch. Using brush (or eye dropper) dribble blobs of paint over surface of liquid starch. Rake comb or nail through paint to create rippled patterns on the surface of the starch.
3. Gently lay construction paper on surface of starch. Pat down evenly with hands to remove air pockets.
4. Lifting one end of paper, slowly pull up off starch. Marbled paint should adhere to paper. Rinse excess starch off in sink; lay flat to dry on newspapers.
5. Transfer drawing of desired subject matter to dried marbled paper. Paint with acrylics.

NOTES:
1. Liquid starch may be used many times – clean by dragging paper towel or newspaper strips across surface. Store covered.
2. Students can be working on drawings for paintings while waiting turn to marble paper.

EVALUATION

Did students
1. Produce a marbled pattern of paint on the surface of a paper?
2. Use acrylics to paint a design or image on the marbled paper?
3. Evaluate completed work?

PROPORTION

PROPORTION: Principle of design concerned with the size relationships of parts of a composition to each other and to the whole.

UNIT: **PROPORTION**		
PROJECT: SCALE COLLAGE SCENES	LEVEL:	☑ 6th ☑ 7th ☑ 8th

OBJECTIVES

Students will

1. Identify scale as size measured against a standard.
2. Create two collage scenes: one in realistic, accurate scale, one in unrealistic scale.
3. Recognize scale and proportion as evidenced in artwork.
4. Evaluate the use of scale and proportion in artwork.

MATERIALS & PREPARATION

- magazines, catalogs, newspapers
- white or colored construction paper (two per student)
- scissors
- markers
- white glue or rubber cement

INSTRUCTIONAL RESOURCES

- **The Art of Collage** by Gerald Brommer
- **ArtTalk** by Rosalind Ragans, pp. 279–281
- Pop Art

VOCABULARY

proportion	unrealistic scale
scale	
collage	
realistic scale	

MOTIVATION/GUIDED EXPLORATION

Show and discuss examples of artwork that demonstrate proportion in realistic and unrealistic scale. Explain that there must be some measure of reference to determine relative scale, and whether the size relationships in a work are realistic or unrealistic.

Demonstrate all procedures.

PROCEDURE

1. Look through magazines, catalogs, and newspapers; cut out people and objects.
2. Create two collage scenes by arranging the cutouts on two separate sheets of paper.
3. On one, arrange cutouts to create a scene in which all people and objects are in correct proportion to each other.
4. On the other, arrange cutouts in a scene in which people and objects are not in scale.
5. Glue down cutouts and draw a background environment for each using markers.
6. Display collage scenes together.

EVALUATION

Did students
1. Create both a realistic and unrealistic scale collage scene?
2. Use materials and supplies correctly?
3. Evaluate realistic and unrealistic scale in artwork?

UNIT:	**PROPORTION**		
PROJECT: THE HUMAN FIGURE	**LEVEL:**	☑ 6th ☑ 7th ☑ 8th	

OBJECTIVES

Students will

1. Identify proportion as a principle of art.
2. Measure and draw the human body with average proportions.
3. Recognize that artists use proportion and distortion to create meaning.
4. Evaluate proportion as evident in works of art.

MATERIALS & PREPARATION

• drawing paper
• erasers
• rulers
• pencils or other drawing tools
• Optional: teacher-made handout of average human body proportions

INSTRUCTIONAL RESOURCES

• **ArtTalk** by Rosalind Ragans, pp. 273–284

VOCABULARY

proportion	distortion
scale	exaggeration
Golden Mean	

PROCEDURE

FOR THE TEACHER:
Explain that the unit used to define the proportions of the average human figure is the length of the head from the top of the skull to the chin. The average adult is 7-1/2 heads tall.

1. Lightly sketch on paper guidelines for human figure (horizontal lines to measure 7-1/2 heads tall).
2. Sketch in parts of body in correct positions.
3. Refine drawing to present proportions and details of actual subject.
4. Erase guidelines and complete drawing in chosen medium.

EXTENSION:
Use distortion or exaggeration to express ideas or feelings about subject.

MOTIVATION/GUIDED EXPLORATION

Show and discuss slides or prints of artworks that display the human figure.

Explain the Golden Mean, a ratio (1 to 1.6) considered by the ancient Greeks to be the ideal proportion, and its relationship to the human figure (when dividing the average human figure at the navel, the resulting measurements have a ratio of 1 to 1.6).

EVALUATION

Did students
1. Draw a human figure using correct proportions?
2. View and critique art works that portray the human figure?
3. Evaluate finished work?

DRAWING THE HUMAN FIGURE
FRONT VIEW

1	
	Head
2	
	Shoulders
3	
	Waist
4	
	Hips
5	
6	
	Knees
7	
	Calves
7-1/2	
	Feet

The measurement of the head is used to determine the proportions of the figure. The average adult is 7-1/2 heads tall. Individual proportions will vary depending on the size, shape, and age of subject. Children vary from 5 to 6 heads tall; infants may be only 3 heads tall and have heads proportionately larger to the rest of the body.

Art Lessons for the Middle School

UNIT:	**PROPORTION**		
PROJECT: PORTRAIT or SELF-PORTRAIT	**LEVEL:**	☑6th ☑7th ☑8th	

OBJECTIVES

Students will

1. Identify proportion as a principle of art.
2. Measure and draw the human face with correct proportions.
3. Recognize that artists use proportion and distortion to create meaning.
4. Evaluate proportion as used in works of art.

MATERIALS & PREPARATION

- drawing paper
- pencils or other drawing tools
- erasers
- rulers
- teacher-made handout of average human facial proportions
- mirror

INSTRUCTIONAL RESOURCES

- Slides and/or prints of portraits and self-portraits by artists
- **ArtTalk** by Rosalind Ragans, pp. 285–287

VOCABULARY

proportion
scale
distortion
exaggeration

MOTIVATION/GUIDED EXPLORATION

Show and discuss slides or prints of portraits.
Lead students in discussion and discovery of average human facial proportions:

The shape of the head, as viewed from the front, is basically an oval. A line down the center divides it into two symmetrical halves. The head is divided horizontally by three lines into four equal parts. The eyes lie on the central horizontal line and the tip of the nose lies on the lowest horizontal line.

PROCEDURE

PORTRAIT:
Use the proportional guidelines to draw a portrait. Sketch guidelines lightly to help in determining shape of head and position of features. Observe subject to refine portrait. Erase guidelines and complete portrait in chosen medium.

SELF-PORTRAIT:
Follow above procedure of using proportional guidelines to begin drawing. Use a mirror to draw self-portrait.

EXTENSION:
Draw portraits of heads turned in different directions; three-quarters view, profile, looking up or down.

Use distortion, exaggeration, or abstraction to create a portrait that shows personality rather than strictly appearance.

EVALUATION

Did students
1. Draw a human face using correct proportions?
2. Develop an individual approach of expression in the portrait?
3. View and critique portraits and self-portraits by adult artists?
4. Evaluate completed work?

DRAWING THE HEAD
FRONT VIEW

1. The head is basically an egg shape, rounder at the top, narrower at the bottom.

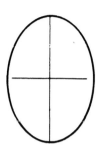

2. Lightly draw a vertical line down the middle of the head shape.

3. Lightly draw a horizontal line to divide the head in half both ways.

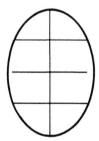

4. Add two more lines to divide head horizontally into 4 equal parts.

5. The inside corners of the eyes are on the middle horizontal line. The space between the eyes is about the width of one eye.

6. The tip of the nose rests on the bottom horizontal line. The ears are aligned with the top of the eyes to the bottom of the nose.

Guidelines are to be used as an aid in drawing the head. Individual faces will vary and must be observed carefully when drawing. Erase guidelines when no longer needed.

7. The mouth is closer to the nose than to the chin.

8. The top fourth of the head is usually covered by hair.

VARIETY, EMPHASIS, AND UNITY

VARIETY: Principle of design concerned with diversity, difference, or contrast.

CONTRAST: Opposition or juxtaposition of differing elements of a composition.

EMPHASIS: Principle of design that stresses an element in a composition to make it more prominent.

UNITY: Principle of design concerned with the effect as a whole of elements, principles, and media in a work of art; a state of "oneness."

UNIT:	**VARIETY**	
PROJECT: VARIATION DRAWINGS	**LEVEL:**	☑6th ☑7th ☑8th

OBJECTIVES	**PROCEDURE**
Students will 1. Identify variety as the principle of art concerned with contrast and difference. 2. Complete series of drawings based on variations of a single object. 3. Recognize that artists use variety to express their ideas and feelings. 4. Evaluate completed work.	1. Choose a simple, easily recognized object (sunglasses, automobile, shoes, etc.). 2. Draw in pencil as many variations of the object as possible. Change shape, size, color, pattern, detail, texture, form in as many ways possible. 3. Use colored markers to complete drawings.

MATERIALS & PREPARATION

• white drawing paper
• pencils
• colored markers

INSTRUCTIONAL RESOURCES

• **ArtTalk** by Rosalind Ragans, pp. 310-311

VOCABULARY

variety/variation
contrast

MOTIVATION/GUIDED EXPLORATION	**EVALUATION**
Show and discuss examples of artworks that use variety to create interest and contrast. Discuss with students variation through changes in shape, size, color, form, texture, pattern, and detail. Explain procedures and show examples of project.	Did students 1. Complete a series of drawings based on variations of a single object? 2. Use color to enhance variety in the drawings? 3. Critique completed work?

UNIT: **VARIETY**		
PROJECT: FOUR-WAY DRAWING	**LEVEL:**	☑6th ☑7th ☑8th

OBJECTIVES

Students will

1. Identify variety as the principle of art concerned with contrast and difference.
2. Recognize that artists use variety to express their ideas and feelings.
3. Complete four drawings of the same subject using different media and techniques.
4. Evaluate completed work.

MATERIALS & PREPARATION

- newsprint paper, 4-1/2"x8"
- white drawing paper, 8"x18"
- pencils
- colored markers, fine point
- colored pencils
- masking tape

INSTRUCTIONAL RESOURCES

- *ArtTalk* by Rosalind Ragans, pp. 310-311

VOCABULARY

variety/variation	line
contrast	value
Pointillism	color

PROCEDURE

1. Choose subjects for drawing (shells, fish, insects, animals, vehicles, etc.). Use pencil to draw (in line only) on newsprint.
2. Fold paper into four equal sections. Transfer drawing in center of each of the four sections (shade back of newsprint with pencil, tape drawing side up to white paper, trace with pencil).
3. Complete the four drawings as follows:
 a. Pencil, line only
 b. Pencil, line and value
 c. Color pencil or marker, line and value
 d. Stippling (Pointillism), color markers, color and value

MOTIVATION/GUIDED EXPLORATION

Show and discuss artworks that use variety to create interest and contrast.

Discuss variation with students through changes in value, color, and texture.

Explain procedures and show examples of project.

EVALUATION

Did students
1. Complete a series of drawings of the same subject using different media and techniques?
2. Follow directions as given?
3. Critique completed work?

UNIT:	**EMPHASIS**	
PROJECT: EMPHASIS DRAWING EXERCISE	**LEVEL:**	☑ 6th ☑ 7th ☑ 8th

OBJECTIVES	**PROCEDURE**
Students will 1. Identify emphasis as the principle of art that makes one part of a work dominant over the other parts. 2. Change the emphasis of a composition through a series of drawings. 3. Recognize the use of emphasis in exemplary works of art. 4. Evaluate emphasis in artwork.	1. Divide white drawing paper (by folding or drawing) into eight equal sections. 2. Using an art reproduction as the subject, draw it eight times, changing the emphasis in each drawing (use pencil & marker as desired): a. Draw the subject as accurately as possible. b. Isolate one element of the composition (example – draw all in line, add value to only one element). c. Change the shape of the subject of the composition through elongation or distortion. d. Change the colors in the composition. e. Change the textures in the composition. f. Change the location of the subject of the composition (center or off-center). g. Change all values in the composition. h. Add something unusual or unexpected to the composition.

MATERIALS & PREPARATION	
• postcard or other small reproductions of exemplary works of art (one per student) • white drawing paper, 12"x18" • pencils • colored markers	

INSTRUCTIONAL RESOURCES	
• **ArtTalk** by Rosalind Ragans, pp. 312-319 • **Emphasis** by Joseph Gatto • **Teaching Drawing from Art** by Brent Wilson, Al Hurwitz, and Marjorie Wilson, pp. 61-75	

VOCABULARY	
emphasis focal point center of interest	

MOTIVATION/GUIDED EXPLORATION	**EVALUATION**
Show and discuss artworks that emphasize various elements in different ways. Discuss with students the focusing of attention in artwork through contrast, isolation, location, convergence, and the use of the unexpected. Explain procedures and distribute art reproductions.	Did students 1. Create a series of drawings that show changes in emphasis? 2. Follow directions as given? 3. Critique finished work?

UNIT:	**UNITY**		
PROJECT: ERASER STAMP PRINTING (REPEAT PATTERN)	**LEVEL:**	☑6th ☑7th ☑8th	

OBJECTIVES

Students will

1. Identify unity as a principle of design.
2. Recognize that the repetition of parts of a design tends to create unity.
3. Recognize unity and pattern in exemplary works of art.
4. Plan and cut a design from an eraser, and use it to print a repeat pattern.
5. Evaluate repeat patterns in artwork.

MATERIALS & PREPARATION

- gum erasers (one per student)
- pencils or markers
- colored construction paper
- tempera paint in jars, assorted colors
- brushes
- craft knives
- containers of water

INSTRUCTIONAL RESOURCES

- **Art from Many Hands** by Jo Miles Schuman, pp. 7-13
- **Pattern** by Albert Porter
- **Balance and Unity** by George Horn

VOCABULARY

pattern	repeat pattern
repetition	alternating pattern
multiple	

PROCEDURE

1. With a pencil or marker, draw a simple design on the flat surface of an eraser.
2. Cut out negative areas with a craft knife. (The teacher may choose to do the cutting after students draw designs.)
3. Apply an even layer of tempera paint to the stamp with a brush.
4. Press print down on paper, then carefully lift off stamp.
5. Print with stamp to create a repeat pattern (repaint stamp after each impression).
6. Hang paper or lay flat to dry.

EXTENSION:
 Use stamps to create a design on fabric.

MOTIVATION/GUIDED EXPLORATION

Show and discuss examples of repeat pattern in artworks.

Demonstrate all procedures.

EVALUATION

Did students
1. Plan and cut a simple design from an eraser?
2. Use stamps to print a repeat pattern?
3. Print stamp impressions that exhibit clean edges and consistent print surface?
4. Evaluate printed repeat patterns?

UNIT: **UNITY**	
PROJECT: MIXED-MEDIA COLLAGE	LEVEL: ☑6th ☑7th ☑8th
OBJECTIVES	**PROCEDURE**
Students will 1. Identify unity as a principle of design concerned with an artwork as a whole. 2. Create a mixed-media collage based on a unifying idea. 3. Recognize unity in exemplary works of art. 4. Evaluate the use of unity in artwork.	1. Choose an idea or theme that will unify a composition. 2. Plan a composition with rough sketches on newsprint. 3. Collect papers needed for collage from colored tissue paper, colored magazine cutouts, wallpaper books, and construction paper. 4. Cut or tear papers and arrange on background paper as decided. Use thinned white glue or polymer medium to attach papers on collage. Brush adhesive on background paper rather than on tissue. 5. When collaged design is complete, let dry. 6. Further details may be added with colored markers.
MATERIALS & PREPARATION	
• newsprint • scissors • white drawing or heavyweight paper • white glue and/or polymer medium • brushes • colored markers • colored pages from magazines • colored tissue paper • other types of paper	
INSTRUCTIONAL RESOURCES	
• **ArtTalk** by Rosalind Ragans, pp. 319-333 • **The Art of Collage** by Gerald Brommer • **Creating With Tissue Paper** by Barbara Stephan	
VOCABULARY	
unity simplicity harmony proximity repetition continuation theme	
MOTIVATION/GUIDED EXPLORATION	**EVALUATION**
Show and discuss works of art that exhibit unity. Discuss with students different unifying devices, such as repetition, simplicity, harmony of color or shape, proximity, and continuation. Brainstorm ideas for unifying themes for collages or assign a variety of specific choices.	Did students 1. Plan and create a tissue and found-paper collage to illustrate the concept of unity? 2. Use a number of unifying devices in the collage? 3. Critique completed work?

UNIT: **UNITY**	
PROJECT: GROUP PROJECT MURAL	**LEVEL:** ☑6th ☑7th ☑8th

OBJECTIVES	PROCEDURE
Students will 1. Identify unity as a principle of art. 2. Recognize unity in murals. 3. Work together as a group to design and paint a mural. 4. Evaluate exemplary murals and completed group project.	1. Brainstorm ideas for the mural. 2. Draw sketches for all or part of the mural. 3. Assemble all sketches and decide on unifying devices. 4. Organize sketches into a final design. 5. Make scale drawings and color renderings of final design. Present to appropriate person for approval. 6. Divide responsibilities among class or team members. 7. If needed, paint mural area with coat of white paint to provide clean painting surface. 8. Enlarge drawings onto the wall by using an opaque projector or by enlarging grid method. 9. Protect work area with drop cloths. 10. Paint mural. 11. Clean up after each work session and on completion. 12. Present mural to the school in a planned ceremony.
MATERIALS & PREPARATION • drawing paper, cut to scale for proposed mural site • pencils • markers • opaque or overhead projector • latex wall paint, white and colors as needed • assorted brushes • drop cloths • ladders, if needed	
INSTRUCTIONAL RESOURCES • Prehistoric cave art, frescoes • Related artists: 　Diego Rivera　　　Michelangelo 　Grant Wood　　　Marc Chagall 　Thomas Hart Benton	
VOCABULARY 　mural 　unifying theme	

MOTIVATION/GUIDED EXPLORATION	EVALUATION
Show and discuss slides of murals. Discuss the historical use of murals, which were often in grand scale and with monumental quality. Visit site for proposed mural with the class and discuss specific considerations needed to design a mural for the site. Measure the area for the mural.	Did students 1. Design a mural appropriate for the site? 2. Make scale drawings and color renderings of designs for mural? 3. Assemble ideas and combine in a unifying theme? 4. Enlarge drawings onto the wall? 5. Protect work area while painting? 6. Evaluate completed mural?

ART HISTORY

ART HISTORY: Study and evaluation of the work of visual artists from prehistoric to modern times.

UNIT:	**ART HISTORY**			
PROJECT: FOCUS ON AN ARTWORK		**LEVEL:**	☑6th ☑7th	☑8th

OBJECTIVES

Students will

1. View, discuss and analyze a specific work of art to determine artist's name and nationality, materials and techniques used, and the date of the work.
2. Recognize distinguishing characteristics that identify a specific artwork as relating to a particular style or culture.
3. Distinguish reproductions from originals.

MATERIALS & PREPARATION

- slides, prints, or other reproductions
- world map or globe
- Optional: teacher-made study guide

INSTRUCTIONAL RESOURCES

- Resources for reproductions: Art supply catalogs

VOCABULARY

artistic style

PROCEDURE

FOR THE TEACHER:
Use a question-asking approach to guide students through discussion and analysis of a specific artwork.

DISCUSSION TOPICS:
1. Attributes of work shown — artist's name, name of work, date of work, size of work, where produced, materials and techniques used.
2. Originating culture and historical period.
3. Subject matter and symbolic representation.
4. Difference in original and reproduction.
5. Function or purpose intended by artist.

MOTIVATION/GUIDED EXPLORATION

Present a slide, print, other reproduction or original artwork to class for observation, analysis, and discussion.

EVALUATION

Did students
1. Identify attributes of a specific work of art?
2. Examine the culture and historical period from which the work originated?
3. Distinguish reproductions from originals?

UNIT:	**ART HISTORY**			
PROJECT: FOCUS ON THE ARTIST		**LEVEL:**	☑6th ☑7th	☑8th

OBJECTIVES	**PROCEDURE**
Students will 1. Identify distinguishing characteristics that associate artworks with a particular artist. 2. Recognize that historical events influence artists. 3. Distinguish reproductions from originals.	FOR THE TEACHER: Use a question-asking approach to guide students through discussion and analysis of the work of a specific artist. DISCUSSION TOPICS: 1. Individual attributes of works shown — name of work, date of work, size of work, when produced, materials and techniques used. 2. Influence of culture and historical period on the artist. 3. Artist's representation of subject matter. 4. Evolution of the artist's work over time. 5. Lasting influences of the artist's work. 6. Function or purpose intended by the artist. 7. Difference in original and reproduction.

MATERIALS & PREPARATION	
• slides, prints, or other reproductions representative of the work of a particular artist • world map or globe • Optional: teacher-made study guide	ADDITIONAL: • Place artist in appropriate chronology on time line. • Create an artwork using similar materials and techniques as those used by the artist.

INSTRUCTIONAL RESOURCES	
• **Art History for Young People** by H.W. Janson • Resources for reproductions: Art supply catalogs	

VOCABULARY	
artistic style artist	

MOTIVATION/GUIDED EXPLORATION	**EVALUATION**
Present slides, prints, other reproductions, or original works of art by a specific artist for observation, discussion, and analysis by class.	Did students 1. Identify similar characteristics in a number of works of a specific artist? 2. Examine the cultural and historical influences on the artist? 3. Distinguish reproductions from originals?

UNIT:	ART HISTORY		
PROJECT: FOCUS ON AN ARTISTIC STYLE	**LEVEL:**	☑6th ☑7th	☑8th

OBJECTIVES	PROCEDURE
Students will 1. Recognize movements and styles in the history of art. 2. Identify specific features and methods of an artistic style. 3. Distinguish reproductions from originals.	FOR THE TEACHER: Use a question-asking approach to guide students through discussion and analysis of a specific artistic style. DISCUSSION TOPICS: 1. Similarities in attributes of works shown. 2. Influence of originating culture and historical period. 3. Evolution and changes in style over time. 4. Similarities in subject matter and symbolic representation. 5. Subsequent influences. 6. Difference in originals and reproductions. ADDITIONAL: • Create an art work in the artistic style studied. • Compare two or more artistic styles.
MATERIALS & PREPARATION • slides, prints, or other reproductions of a number of art works representative of a particular artistic style • world map or globe • Optional: teacher-made study guide	
INSTRUCTIONAL RESOURCES • **Art History for Young People** by H.W. Janson • **ArtTalk** by Rosalind Rogans, pp. 25-45 • Resources for reproductions: Art supply catalogs	
VOCABULARY artistic style culture movement period	
MOTIVATION/GUIDED EXPLORATION	**EVALUATION**
Present slides, prints, or other reproductions of a number of works of art in a specific artistic style for viewing, discussion, and analysis by class.	Did students 1. Recognize distinguishing characteristics of a specific artistic style? 2. Examine the culture and the historical period from which the style originated? 3. Differentiate reproductions from originals?

ART CRITICISM

ART CRITICISM: Description, analysis, interpretation, and judgment of a work of art.

UNIT:	**ART CRITICISM**			
PROJECT: CRITICIZING A WORK OF ART	**LEVEL:**	☑6th	☑7th	☑8th

OBJECTIVES

Students will

1. Objectively describe a work of art.
2. Distinguish the elements and principles of art in an artwork.
3. Interpret the meaning of an artwork.
4. Evaluate a work of art.

MATERIALS & PREPARATION

• slides, prints, other reproductions, or original works of art

INSTRUCTIONAL RESOURCES

• **ArtTalk** by Rosalind Ragans, pp. 13–23

VOCABULARY

art criticism judgment
description
analysis
interpretation

PROCEDURE

Use a question-asking approach to lead students in discussion of the artwork. Discussion proceeds through four steps:

1. Description — size and medium of work, objective subject matter.
2. Analysis — identify elements and principles of art used in the work.
3. Interpretation — explain or tell the meaning of the work (based on observation).
4. Judgment — evaluation and opinion of work.

EXTENSIONS:
1. Students can apply the four steps of art criticism to analyze their own work.
2. Provide opportunities for students to write critical responses to works of art.

MOTIVATION/GUIDED EXPLORATION

Present an artwork to the class as a slide, print, or in original form. Explain that students will describe, analyze, interpret, and judge the work.

Give students a few minutes to look and respond before analyzing the artwork.

EVALUATION

Did students
1. Indicate size, medium, and subject matter?
2. Describe the elements and principles of art evident?
3. Interpret the artist's meaning?
4. Express individual evaluation of the work?

AESTHETICS

AESTHETICS: Study of the qualities perceived through the mind and emotions in works of art.

1992 J. Weston Walch, Publisher* *Art Lessons for the Middle School*

UNIT:	**AESTHETICS**		
PROJECT: AESTHETIC SCANNING	**LEVEL:**	☑6th	☑7th ☑8th

OBJECTIVES

Students will

1. Experience direct sensory responses to works of art.
2. Identify and discuss sensory, formal, technical, and expressive properties of works of art.
3. Recognize objective standards for establishing criteria for the valuation of specific works of art.
4. Distinguish between personal preferences and objective judgments of works of art.

MATERIALS & PREPARATION

- slides, prints, or examples of works of art

- Optional: teacher-made study sheets, pencils

INSTRUCTIONAL RESOURCES

- "Buried Treasures: Aesthetic Scanning with Children" by Gloria Hewett and Jean Rush, Art Education, January 1987, pp. 41-43.

VOCABULARY

aesthetics	principles of art
aesthetic scanning	evaluation
elements of art	

MOTIVATION/GUIDED EXPLORATION

Present slides, prints, or actual works of art to students for observation and discussion (this may include both exemplary works of adult art and student work).

PROCEDURE

FOR THE TEACHER:
Students will identify and discuss art works through their sensory, formal, technical, and expressive qualities.

SENSORY: The elements of art, line, shape, color, value, texture, form, space.
FORMAL: The principles of art, rhythm, movement, balance, proportion, variety, emphasis, unity.
TECHNICAL: Media, tools, processes, and the artist's reasons for choosing them.
EXPRESSIVE: Mood, emotion, message, or idea conveyed by the artist.

Guide students through discussion of the above qualities of a work of art. Start with simple questions, then gradually increase complexity of questions to initiate answers and elaborate responses.

NOTE:
Study sheets may be used to aid students in developing a more descriptive aesthetic vocabulary.

EVALUATION

Did students
1. Express verbally and/or in written form direct sensory responses to works of art?
2. Identify and/or discuss sensory, formal, technical, and expressive properties of works of art?
3. Indicate personal preferences in evaluating works of art?
4. Recognize objective standards for evaluating artwork?

Bibliography

Anderson, Marilyn. *Guatemalan Textiles Today*. New York: Watson-Guptill Publications, 1978.

Battin, Margaret P., et al. *Puzzles About Art: An Aesthetics Casebook*. New York: St. Martin's Press, 1989.

Borgeson, Bet. *Color Drawing Workshop*. New York: Watson-Guptill Publications, 1984.

————. *The Colored Pencil*. New York: Watson Guptill Publications, 1983.

Brommer, Gerald. *The Art of Collage*. Worcester, MA: Davis Publications, Inc., 1978.

————. *Exploring Drawing*. Worcester, MA: Davis Publications, Inc., 1988.

————. *Movement and Rhythm*. Worcester, MA: Davis Publications, Inc., 1975.

————. *Relief Printmaking*. Worcester, MA: Davis Publications, Inc., 1970.

————. *Space*. Worcester, MA: Davis Publications, Inc., 1974.

————. *Wire Sculpture*. Worcester, MA: Davis Publications, Inc., 1968.

Brommer, Gerald, and Nancy Kinne. *Exploring Painting*. Worcester, MA: Davis Publications, Inc., 1988.

Curtis, Cécile. *The Art of Scratchboard*. Cincinnati, OH: North Light Books, 1988.

Cutler, Merritt. *How to Cut Drawings on Scratchboard*. New York: Watson-Guptill Publications, Inc., 1986.

Encisco, Jorge. *Design Motifs of Ancient Mexico*. New York: Dover Publications, Inc., 1953.

Escher, M.C., and J.C. Locher. *The World of M.C. Escher*. New York: New American Library, 1974.

Finkel, Norma, and Leslie Finkel. *Kaleidoscope Designs and How to Create Them*. New York: Dover Publications, Inc., 1980.

Gatto, Joseph. *Color and Value*. Worcester, MA: Davis Publications, Inc., 1975.

————. *Emphasis*. Worcester, MA: Davis Publications, Inc., 1975.

Hathaway, Walter. *Art Education: Middle/Junior High School*. Reston, VA: National Art Education Association.

Hewett, Gloria, and Jean Rush. "Buried Treasures: Aesthetics with Children," *Art Education*, January 1987.

Hoopes, Donelson F. *Winslow Homer Watercolors*. New York: Watson-Guptill Publications, 1969.

Horn, George. *Balance and Unity*. Worcester, MA: Davis Publications, Inc., 1975.

Itten, Johannes. *The Art of Color*. New York: Reinhold Publication Corporation, 1961.

Jablonski, Ramona. *The Paper Cut-out Design Book*. Owings Mills, MD: Stemmer House, 1976.

Janson, H.W., and Anthony F. Janson. *History of Art for Young People*. New York: Harry N. Abrams, Inc., Publishers, 1987.

Leslie, Kenneth. *Oil Pastel: Materials & Techniques for Today's Artist*. New York: Watson Guptill Publications, 1990.

Michael, John, A. *Art and Adolescence: Art in Secondary Schools*. New York: Teachers College Press, 1988.

Mittler, Gene A. *Art in Focus*. Mission Hills, CA: Glencoe Publishing Company, 1989.

Porter, Albert. *Expressive Watercolor Techniques*. Worcester, MA: Davis Publications, Inc., 1982.

————. *Pattern*. Worcester, MA: Davis Publications, Inc., 1975.

Ragans, Rosalind. *ArtTalk*. Mission Hills, CA: Glencoe Publishing Company, 1988.

Rodriguez, Susan. *Art Smart!* Englewood Cliffs, NJ: Prentice-Hall, 1988.

Sapiro, Maurice. *Clay Handbuilding*. Worcester, MA: Davis Publications, Inc., 1979.

Schuman, Jo Miles. *Art from Many Hands*. Worcester, MA: Davis Publications, Inc., 1981.

Segy, Ladislas. *Masks of Black Africa*. New York: Dover Publications, Inc., 1976.

Sivin, Carole. *Maskmaking*. Worcester, MA: Davis Publications, Inc., 1986.

Stephan, Barbara. *Creating with Tissue Paper*. New York: Crown Publishers, Inc., 1973.

Stephens, Keith. "An Architectural Orientation to Paper," *Arts & Activities*, October 1987.

Williams, Geoffrey. *African Designs from Traditional Sources*. New York: Dover Publications, Inc., 1971.

Wilson, Brent, Al Hurwitz, and Marjorie Wilson. *Teaching Drawing from Art*. Worcester, MA: Davis Publications, Inc., 1989.